Photograph
Your Art & Craft

7

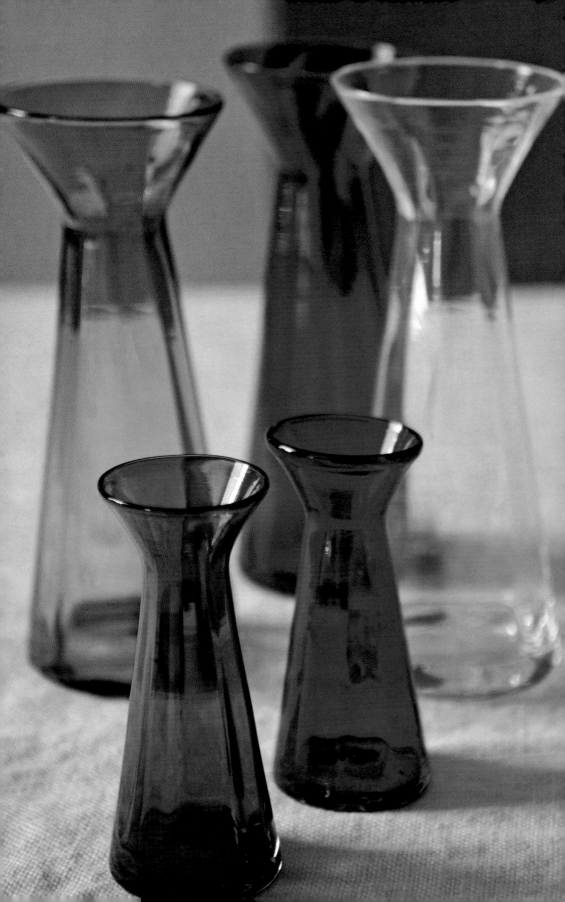

Photograph Your Art & Craft

Sussie Ahlburg

A & C Black • London

First published in Great Britain in 2011
A & C Black Publishers Ltd, an imprint of
Bloomsbury Publishing Plc
50 Bedford Square
London WC1B 3DP
www.acblack.com

ISBN 978-1-408-13102-2

Book design by Penny Mills
Cover design by Sutchinda Rangsi Thompson
Project editor Alison Stace

Printed and bound in China.
This book is produced using paper that is made from wood grown in
managed, sustainable forests. It is natural, renewable and recyclable. The
logging and manufacturing processes conform to the environmental
regulations of the country of origin.

frontispiece: *Linda and Lena Design, glass vases. Height: (large) 25cm (9¾in) and (small) 15cm (6in).*

Contents

Simple chart for image size & format

PURPOSE OF IMAGE	USUAL SIZE NEEDED
Images for emailing Website images	Jpegs (72dpi)
Photos for display Portfolios Cards Brochures Publications	Tiffs (minimum 300dpi)

NB: These are guidelines only. You will need different resolutions and file size for various applications but always take your photos at the highest resolution possible as you can downsize your images and save them as a copy in a lower resolution tiffs or jpegs. Check what is needed first as different web designers and printers will have specific requirements.

which we are surrounded by images, we've come to expect photographs to be both eye-catching and of good quality.

There are many different ways of promoting your work using photographs so, before you pick up your camera, you need to think about how and where they will be used. Will they be for cards or brochures, or websites and portfolios? Do you want to email them to promoters and buyers or display them at trade shows? Are they for publications, galleries or magazines? You will need to tailor your images for different purposes.

Websites

If you are making a website, it's a good idea to think first about the style, design and purpose of the site. You might need clear product shots (especially if you're selling from your site), but also beautiful imaginative images that will capture people's attention. It might also make sense to take photos of any packaging, as this will give an idea of how your work is presented to the customer. You might need explanatory images or several photos taken of the same object to illustrate your product clearly. You might want your object photographed in a setting or on a model.

Whatever you choose to do, it's important to have continuity and consistency as well as high-quality images. Don't be tempted to include a poor photo of a piece of work just because you don't have anything better, as this can degrade the overall look of your website. Website designers usually work with 72dpi JPEG images (50–60KB), but ask your designer first, as they may be happy to convert your images to be suitable for the web. If you are using a DIY website program, this will tell you the size required.

Photos for display

If you are taking photos for display at exhibitions, trade shows or craft fairs, make sure you use a good photographic printer and give them high-resolution TIFF files or film to print from. You might also ask to look at some different paper finishes and consider having your pictures mounted or framed.

Portfolios

For portfolios, again it is important to have high-quality photographs with continuity and consistency across all the pictures. Have the images printed from film or high-resolution 300dpi TIFFs onto good paper. You might also want to have the photographs dry-mounted on board. Placing your images in individual acetate sheets or covering them in a plastic adhesive film provides extra durability. It can be costly putting together an impressive portfolio but it's worth making it a pleasure to look at and handle.

Cards

For cards try to create images that will catch the viewer's eye, whether that is a strong product or location photograph or a detail of your work. Contact your printer and ask for their technical requirements before you start designing your card. Printers normally require print-sized uncompressed images of at least 300dpi, usually delivered as a PDF with a bleed of 3mm (a 'bleed' means allowing some extra image at the edge to be cropped off when the paper is trimmed to size). Ask the printer for a proof and check carefully for any mistakes and colour shift.

Brochures

The design, layout and images in a brochure should be complementary in order to maintain the viewer's interest. Have the finished look, design and layout of the brochure planned before you start taking photographs, making sure the images work together in an interesting way.

Galleries

For galleries you will need high-quality pictures that clearly represent your work, with everything well-lit and in focus. Galleries often like images taken on white backdrops using soft light (no hard shadows to distract from the object).

Competition, grant and awards applications

Look carefully at the application requirements to make sure that your images are the correct size and resolution (some applications also specify that the images must be in either landscape or portrait format). The jury will want to see strong professional images, clearly photographed on a neutral background.

Publication

Photographs for publication need to be high-quality uncompressed images of at least 300dpi, preferably in TIFF format.

Whoever the prospective viewer – competition judges, selectors for craft fairs, gallery owners, art editors for magazines or books, buyers for shops – they will not see the quality, craftsmanship and beauty of the object behind a badly taken photograph. If you respect your work then you will understand the importance of presenting it in the best way possible.

Before you start taking pictures it might be useful to look at relevant images on websites and in magazines, books and brochures. Look carefully and try to identify what it is that you like about an image. Is it the composition; the way the light is falling on the object; the choice of background; the way it's all sharply in focus; or the way the focus is only on a small part of the object? Is there anything you would improve? Then look once more and ask yourself how it was achieved – how was the object lit; what background was used; what lens and aperture were used? Also, look at images you don't like – ask yourself what aspects you dislike and what could be changed to improve the photograph.

Bear in mind that there isn't a right or wrong way to photograph a piece of work – there are only technical mistakes – so if ten different photographers were to photograph the same object, the result would be ten completely different images. Thus it's best before you start to have an idea of the finished image already in your mind (if possible).

Rolls of 35mm film.

Film or Digital

Film and digital cameras work in similar ways because the digital camera is modelled on the film camera. When you press the shutter on a camera the light passes through the lens and the image is captured – in the film camera on light-sensitive film that is then processed by chemicals; in the digital camera by the sensor and stored in digital files on memory cards which are loaded onto your computer and processed electronically.

Digital

The great advantage with shooting on digital is being able to view the image instantly on the LCD screen. This allows you to experiment without the cost of film and processing, saving you both money and time. Be aware, however, that the possibility of 'snapping' lots of photos without having to worry about the cost of film and processing can be unhelpful: hoping for a happy accident is not a substitute for carefully controlling and composing the photograph.

The menu button will take you to a display on the camera's screen where you will find many optional settings. You might never use

Digital data storage memory cards.

The LCD on a 35mm digital SLR camera displaying an image.

The LCD on a 35mm digital SLR camera showing the menu display.

some of these settings, but you should take the time to read about them in your camera's manual so that you know what they are. There are, however, some important settings that you will need to be aware of. These are:

Manual setting: In order to take good professional photographs of your work, set the camera to Manual so you have control of the depth of field, focus and exposure.

ISO: The ISO control setting on a digital camera is a carry-over from film used in cameras. ISO (International Standard Organization) is a standard measure of the camera's sensitivity to light. The higher the ISO setting the less light is needed when taking your photos but the higher the ISO the lower the quality, so if you are using a digital camera choose the lowest ISO setting available. Don't be tempted to change the ISO for shorter exposures; instead use a tripod, cable release and long exposures when necessary to obtain the best quality.

Quality: Set the camera's Quality setting on the highest available, ideally TIFF or Raw. Although you will not always need high-resolution files (for example, you'll need lower-resolution files for website and emailing) it's always best to have the images in high-resolution and downsize them if necessary – you cannot convert low-resolution images to high-resolution. This way you will also avoid having to re-photograph your work if you find that the resolution is not sufficient for a particular application.

TIFFs: (Tagged Image File Format) are standard high-quality files that can be edited and re-saved without loss of quality.

Raw files: These are raw unprocessed data files (sometimes called digital negatives). Raw files

Cable release for digital and film 35mm SLR cameras.

ISO setting on a digital 35mm SLR camera.

File size display on a digital 35mm SLR camera.

are processed by a Raw converter, and adjustments for exposure and white balance can be made with minimum loss of information before they are converted into TIFF or JPEG files. If you want to use a Raw file, make sure you have a program on your computer that can process Raw.

JPEGs: (Joint Photographic Experts Group) are smaller, variably compressed files. With compression comes a consequent loss of picture quality, which is made worse each time an image is edited or re-saved, so do your post-production work with TIFF or Raw files before compressing images into JPEGs.

Whenever you resize an image (or if you alter it in a program such as Photoshop) always save the resized or altered image as a duplication by selecting 'Save As' and renaming it. Always keep your originals backed up on a disk and stored safely.

Post-production

You will need a program such as Photoshop to download images from your camera to your computer, and for post-production work such as correcting the levels of colour, resizing, cropping etc. You can find user guides for Photoshop online or in bookshops. Photoshop tools can be very useful and images can be manipulated almost endlessly, but this can also be very time-consuming. Moreover, you will need to know what you're doing, as an image can easily look 'Photoshopped' in which case the viewer may not trust the veracity of what they are seeing. It is always important to have the best image possible to start with, as a poor image cannot be rescued by post-production.

Storing digital images

Have a dedicated folder on your hard drive where you store your images (not on your desktop, as this will slow down your computer), though bear in mind that large image files will take up a lot of space on your hard drive. Also, if the hard drive fails you might lose them, so store your finished images on disks or back them up on an external hard drive. Get high-quality disks for your images but remember disks can corrupt and are damaged by humidity, so keep them protected in sleeves and hold them at the edges when inserting them into your computer.

Looking after your digital camera

The sensors in digital cameras are very sensitive and even tiny specks of dust will show up as marks on your photograph – these can be recognized by the fact that they are in the same place on every picture. The sensor will need cleaning from time to time, but this should only be done with special cleaning material from a photographic supplier, or else have it cleaned professionally. Never use compressed-air dusters or any other cleaning method to clean the sensor, and don't leave your camera lying around without the lens or camera-body cap in place. When changing the lens, switch off the camera and do it quickly, with the camera facing down in order to minimise dust ingress. Look after all your equipment and it will last. Protect it from dirt, dust, damp and sand, and always carry it in a padded bag when you take it out.

Film

You can get beautiful results by using good professional film, processed in a professional lab. But film and processing are costly, and waiting for the film to be processed before you know if you have made mistakes can be slow and frustrating.

Manual film cameras are built to last and are lovely tools to use. It can be great to have simple control over the shutter, f-stop and focus, without the distraction of digital menus. Many photographers feel that film has a special

top right: *Processed transparency 35mm film.*

right and bottom: *Processed negative film stored in clear negative pages and a printed contact sheet.*

quality that can't be compared to digital. If you already have a good film SLR (Single Lens Reflex) 35mm camera and lenses, you might want to offset the cost of working with film against that of investing in digital equipment.

Scanning negatives or slides

You will find, though, that your photos will most often be required as digital files. Professional photography labs will scan images from negatives and slides into high-resolution TIFFs, but this can be costly (if you must use a high-street lab, be sure to ask what file type and resolution they offer before they do the work).

Film types

If you are using a film camera make sure you use good-quality film from a professional supplier. There are two different types of colour film – transparency (positive, slide film) and negative. Photographers often prefer transparency for this kind of work, as they feel the quality is superior to negative, but it is also more expensive. Transparency film is also less forgiving of exposure errors whereas negative film has wide exposure latitude.

You will also need to know what light source you will be using when photograph-ing your work using film. Flash studio light, daylight and daylight balanced studio light have a blue colour temperature for which you will need daylight-balanced film. Tungsten light has a yellow colour temperature for which you would need tungsten-balanced film, currently however since Tungsten film has been discon-tinued the alternative is to place a blue gel (from photographic supplies) in front of the light.

As mentioned above, film comes in different ISO speeds. As a general rule, faster film produces lower-quality images, so for photographing your work it's best to use a slow film of 100 or 200 ISO. Colour film needs to be stored in a fridge; you should check the 'sell by' date before you use it.

Storing film

When you have had your film processed, in order to protect the negatives and slides from dust and fingerprints, place them in archive slide pockets and negative pages, and store them in a box.

Don't rule out working with film simply because it's not the latest technology, and don't assume current technology to be the best or the last.

Mounted transparency slides stored in protective plastic pocket sheets.

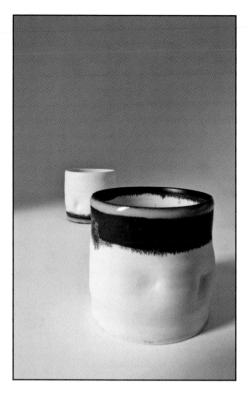

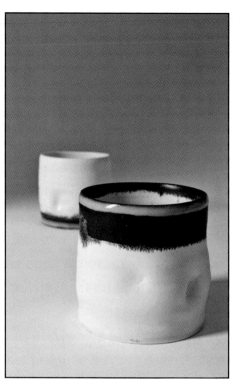

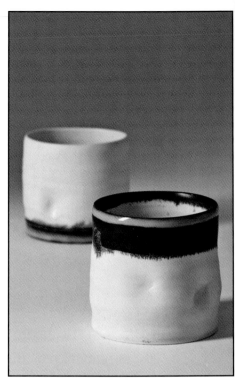

Two ceramic pieces photographed with a wide-angle lens.

Two ceramic pieces photographed with a standard lens.

Two ceramic pieces photographed with a long lens.

Kyra Cane, Tiny Porcelain Pot, *2010. Height: 7cm (2¾in).*
Notice how the use of different lenses changes the perspective and relationship between the two objects.

Normal lens

The 'normal' or 'standard' lens will give you a perspective which is close to how we see things with our eyes. This is sometimes called 'correct perspective'.

Long lens

A long or telephoto lens is longer than standard and can give a more attractive perspective in still-life photography. It will magnify the object in a way that is different to moving closer with a standard lens, compressing the distance between objects and flattening the perspective. Long lenses also make it easier to create a shallow depth of field – creating an image in which the focus is soft, apart from the area where you choose to focus, de-emphasising the foreground and background.

Remember, the longer the lens the shallower the depth of field at the same f-stop.

Zoom lenses

A zoom lens has a variable focal length (as opposed to the fixed focal-length lenses mentioned above), so it's like having two or more lenses in one. There are many different zoom lenses: some are telephoto, some are wide-angle, and others (sometimes referred to as 'normal' zooms) cover a range from wide-angle to telephoto.

Macro lens

If you want to take detailed close-up images of your work, or if your work is small, then you may wish to use a macro lens. A macro lens can also be used as a normal or long lens depending on its focal length – if you have a long macro lens you can use it both for close-up and whole-object photography.

Extension tubes

Another way to take close-up photos of your work is to use extension tubes. These are fairly inexpensive as they have no optical elements, but you will need to extend the exposure time as extension tubes reduce the amount of light reaching the film or sensor. Extension tubes usually come in sets of three, to be used together or individually. Before purchasing the tubes, make sure they are compatible with your camera and lenses.

Digital lens conversion

Lenses for SLR film cameras are interchangeable with lenses for digital SLR cameras as long as they have the same lens mount. It's very important, however, to know that when moving a lens between an SLR and a DSLR camera, the practical focal length of the lens will change. Most digital

right: *Extension tubes.*

Depth of Field

Depth of field is the distance between the nearest and farthest objects in a scene that appear in focus in a photo.

Changing the depth of field when taking photographs will greatly alter the aesthetics of the image. You might want a softer atmospheric image with the use of a shallow depth of field, or you might want to draw the eye to a certain detail in your work or single out a specific piece in a group. You can also isolate the object from the background and de-emphasise the surroundings using a shallow depth of field. Sometimes you might like the clarity, sharpness and overall detail that come with a long depth of field.

If you can't visualise this you might try photographing your set-up using both shallow and long depths of field then considering which of the resulting images you prefer.

Aperture and depth of field

The aperture is the opening in the lens that lets light through to the sensor or film in the camera.

The smaller the opening (narrower aperture), the longer the depth of field, so objects at a wide range of distances will all be in focus and everything in your image will be sharp.

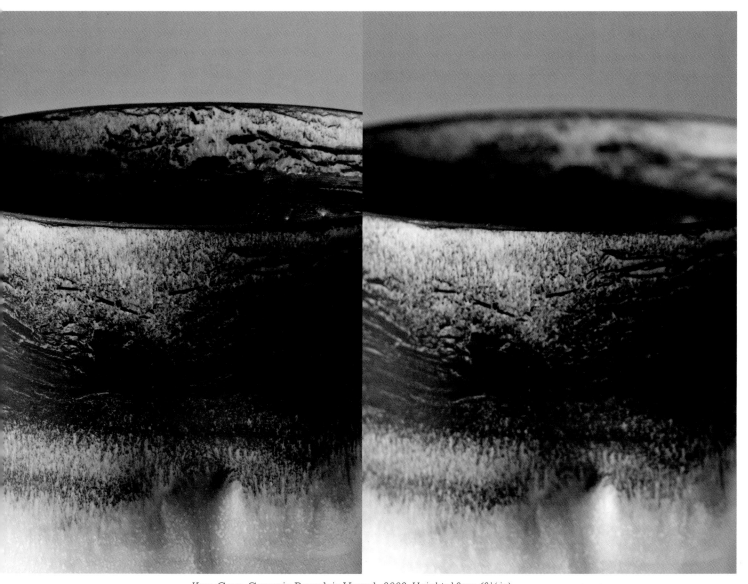

Kyra Cane, Ceramic Porcelain Vessel, *2009. Height: 16cm (6¼in).*

left: *Vessel photographed with a long depth of field to achieve sharpness in the image both in front and behind the vessel.*
right: *Vessel photographed with a short depth of field - the image is sharp only at the focus point, the front of the bowl, with the back of the bowl de-emphasised.*

The bigger the opening (wider aperture), the more shallow the depth of field, so a wider aperture will give you an image that is sharp around the area upon which you choose to focus, but blurred in the background and foreground.

These different aperture settings on the lens are called f-stops, and (confusingly) the smaller the f-stop number, the larger the opening and vice versa.

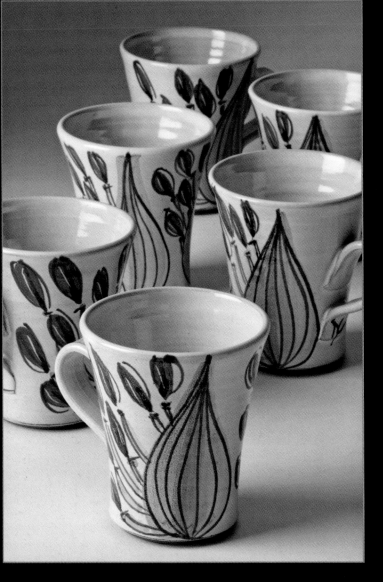

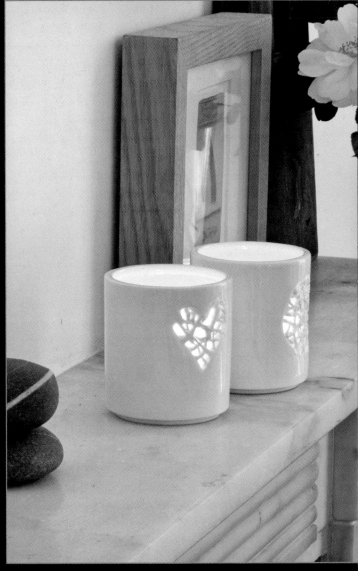

Daphne Carnegie, Mugs, 2010. Tin-glazed earthenware, with agapanthus design. Height: 9cm (3½ in). Photographed with long depth of field resulting in an image where all the mugs are in focus.

Timea Sido, Tangled Heart and Circle Tea Light Holders, 2010. White earthenware. Height: 7.5cm (3in). Photographed on a mantelpiece with a long depth of field creating an image with focus in the background as well as on the tea light holders.

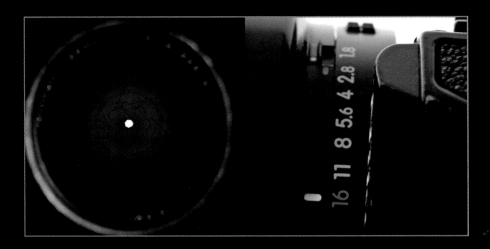

(left) *A lens closed down - using a lens closed down creates a sharp image with a long depth of field - everything in the photo will be in focus.*
(right) *A lens closed down to f16.*

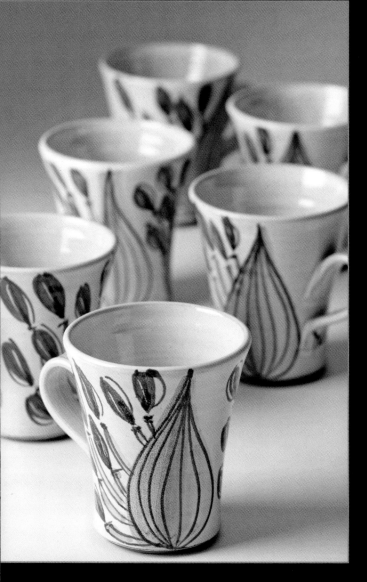

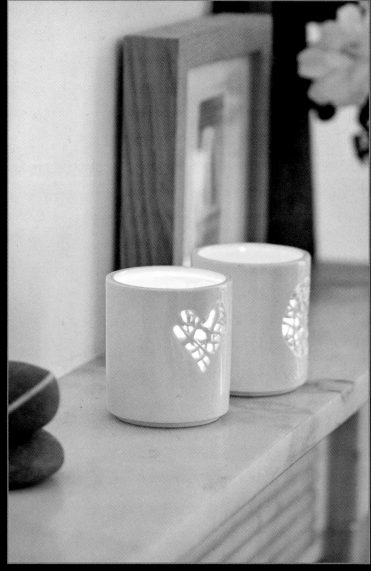

Daphne Carnegie, Mugs, *2010. The group of mugs photographed with shallow depth of field – the focus point is on the front mug which singles it out from the group.*

Timea Sido, Tangled Heart and Circle Tea Light Holders, *2010. The tea light holders are isolated from the background by using a shallow depth of field.*

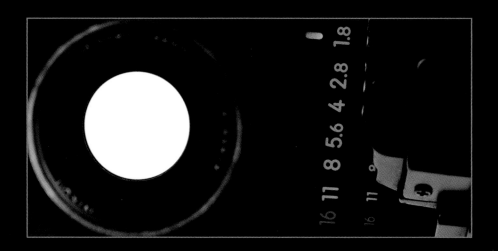

(left) A lens opened up - using a lens opened creates an image with a shallow depth of field where the focus is only on the focus point.

(right) A lens opened up to f1.8.

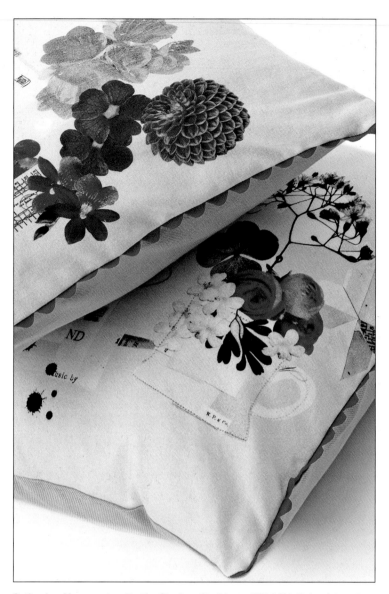

Catherine Hammerton, Bottle Garden Cushions, 2010. Digital print, cotton satin and linen, 40 x 60cm (15¾ x 23½in). Photographed using a long depth of field to clearly show the print on both cushions.

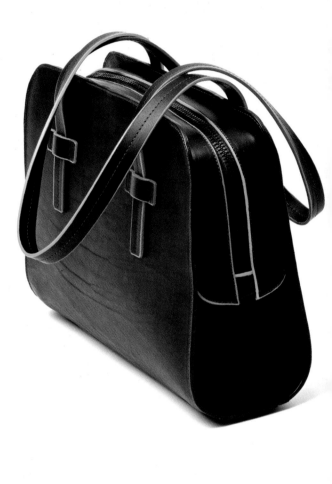

Melissa Simpson, Striped Satchel, 2010. Whisky leather edged in multicolours and lined in a vivid turquoise suede, 26 x 33 x 10cm (10¼ x 13 x 4in). Photographed using a long depth of field to create a crisp, clear product shot.

Depending on your lens and camera, the f-stops will be either set on the lens or selected digitally on the camera body. Different lenses have varying ranges of f-stops, usually somewhere between f1.8 and f32.

When you close the lens to a small opening or narrow aperture, less light will be able to pass through, and when you open to a wide aperture, more light passes through.

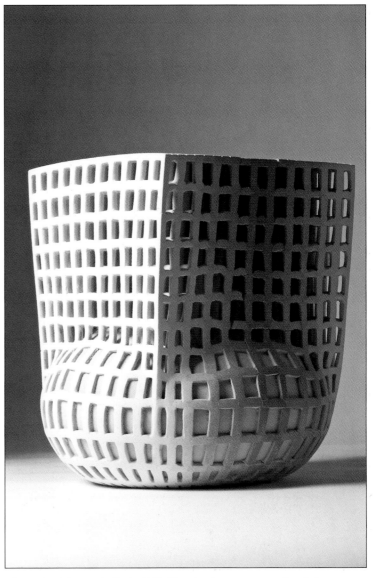

Marie-Therese Ross, Nena (The Trail of Your Blood in the Snow), *2010. Oil Paint on wood, ribbon and cotton fabric. Height: 177cm (69¾in). Photographed with a long depth of field to clearly show the details and textures of the piece.*

Steve Buck, Hyperbolic 2, *2008. Blends of stoneware and red clay, grey pigment. Height: 32.5cm (12¾in). Photographed with long depth of field for a clear impression of the entire piece.*

Shutter speed

The shutter speed determines the length of time the shutter in the camera will be open. When the shutter is open light passes through the lens to the sensor or film. A slow shutter speed will let more light through, as the shutter is open for a longer time; a short shutter speed lets less light through, as it's open for a shorter time.

The shutter speed, depending on the camera, can be set at anything from about a thousandth of a second to several seconds.

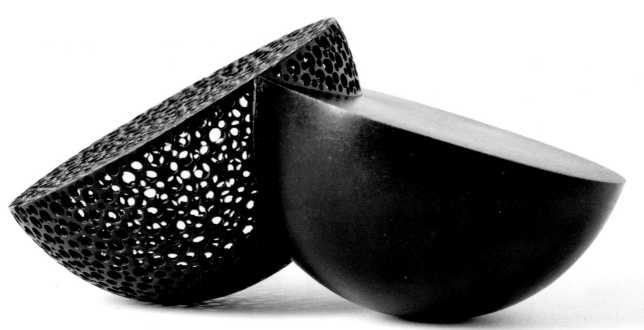

Ane Christenssen, Colliding Bowls, *2010. Patinated copper. Height: 6cm (2½in). Photographed with a long depth of field for an image with overall detail.*

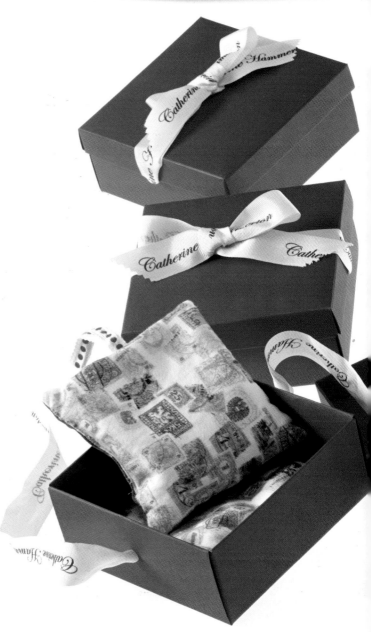

Catherine Hammerton, Stamp-printed Lavender Boxes, *2010. Digital print, cotton sateen, lavender and buckwheat, 14 x 14cm (5½ x 5½in). Photographed with a long depth of field to show the print on the fabric in the foreground as well as the writing on the ribbon on the boxes in the back, to create a clear product image.*

left: *Alison Evans, Jester Bracelet, 2007. Titanium and pearl. Photographed with a very shallow depth of field.*

below left: *Simone ten Hompel, Tea Strainer, 2010. Mixed metal, 10cm (4in). Photographed with shallow depth of field to de-emphasise the objects in the background.*

below right: *Anne Mercedes, Periple, 2009. Porcelain, stoneware, earthenware and feldspar. Height: 10cm (4in) (dimensions of the whole installation 120 (H) x 200 x 100cm/47¾ x 79 x 39½in). Photographed using shallow depth of field to single out the object in front of the installation.*

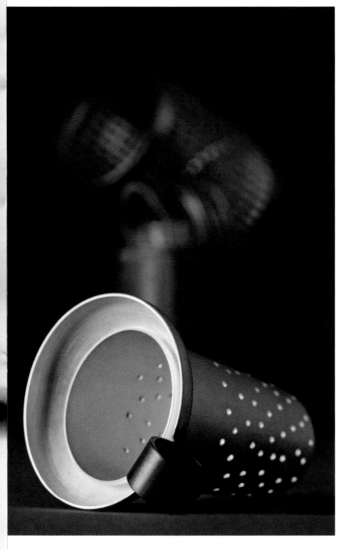

Exposure and Light Readings

Correct exposures will result in photographs with good detail in the light and dark areas as well as true colours. Taking inaccurately exposed photos can lead to dark, dull or bleached-out pictures.

In an overexposed photo the black in the object will look grey and the lighter areas will be burnt out, with little or no detail. In an underexposed photo the darker areas will look black, with little or no detail.

To expose your photos correctly you must learn to read the light in an accurate way. This can be done with the internal light meter in your camera or a separate handheld light meter.

Internal light meter

A camera's internal light meter reads the light reflected off the set-up. However, if the object or background is either very dark or very light, the meter doesn't adjust for this and your image may become over- or under-exposed. This is because the light meter will calculate the readings as if taken from mid-grey tones.

One way around this is to trick the meter by placing a mid-grey exposure card (available from

photographic suppliers) in front of the object. Move the camera so that the grey card fills the viewfinder, take the light reading, remove the grey card, return the camera to the tripod, then compose the image and take your picture.

Handheld light meter

The separate light meter has the advantage of taking very precise light readings. There are two types of light readings possible with a handheld light meter: reflective light reading and incident light reading.

Reflected light readings are taken by pointing the meter at the object, thus reading the intensity of light reflecting off the object back to the camera. The problem with this is that dark or bright areas on the object will give different light readings. Once again, a grey card will overcome this problem.

For an incident light reading, slide the small white dome diffuser (which looks like a rounded button) across on the meter to cover the light cell, then hold the meter near the object but pointing towards the camera, thus reading the intensity of light falling onto the object. (For reflective readings the diffuser dome should not cover the cell.)

 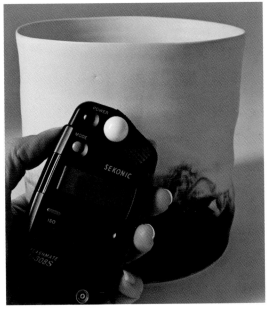

opposite: *Grey exposure card.*
above left: *Taking a reflective light reading with a handheld light meter.*
above right: *Taking an incident light reading using a handheld light meter.*

In summary, light readings will tell you which aperture and shutter speed you need to set on the camera in order to make a correct exposure, but remember when you set these to decide on the aperture you need to get the desired depth of field and then to adjust the shutter speed accordingly.

Balancing f-stops with shutter speed

The aperture and shutter speed correspond: one stop on the aperture equals one stop on the shutter speed. For example, when you want to open the aperture two stops to create a shallower depth of field, you must also make the shutter speed two stops faster. This is because opening the aperture allows in more light and, in order to compensate, the shutter speed needs to be faster to allow less light to reach the sensor or film.

Don't forget to make sure the ISO speed is set correctly on the camera and light meter.

Some objects will benefit from being slightly over- or underexposed so, when you've taken your photo using the correct light reading, try taking one photo with the shutter speed one stop slower and another with the speed one stop faster; this is known as bracketing. If working digitally, only select the exposure you like best when looking at the images on your computer screen, as this will reveal more detail than the LCD on your camera.

For exposures longer than 1/60th of a second always place the camera on a tripod and use a cable release to avoid camera shake. As long as your camera or subject isn't moving you have the option of long exposures.

Light

Light is crucial to photography. The word photography comes from the Greek words Ψῶς (photos), meaning 'light', and Υραφή (graphé), meaning 'representation by means of lines' or 'drawing'. Put together, the two words mean 'drawing with light'.

Light creates shadows and highlights revealing forms, textures and tones. Both the quality and direction of the light will greatly alter the look of your object.

The quality of the light – meaning the nature of the light – can range from diffused light with soft shadows and edges, as on a cloudy day, to very hard light with dense shadows and hard edges, as on a sunny day.

Object photographed using a softbox attached to the studio light – creating soft light.

Object photographed using a spotlight attachment – creating hard light.

41

If the light is soft, the transition from highlight to shadow will be gentle. If the light is hard, the shadows on the object will be dark, with little or no detail.

The direction of the light is governed by the height and angle of the light source.

Placing the light in front of the object will create no shadows and thus will flatten the object. Lighting the object from one side will create a shadowy area on the opposite side, bringing out its form. It will also create shadows in the uneven surfaces within the object, emphasising texture.

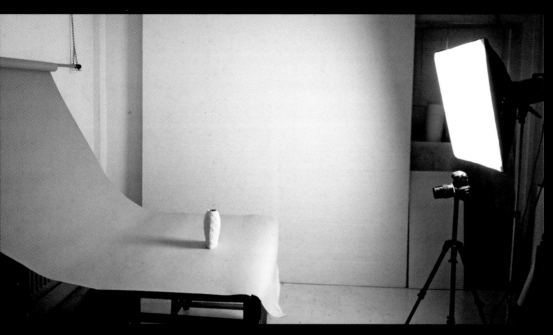 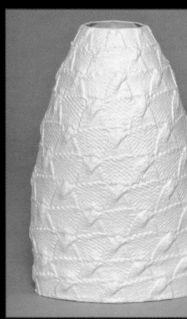

A light is placed in front of the object.

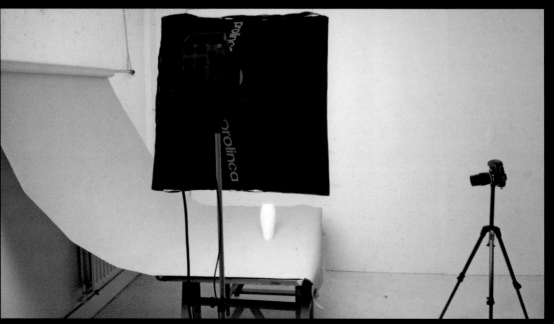 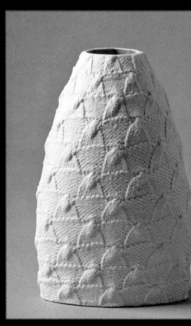

A light is placed on one side of the object.

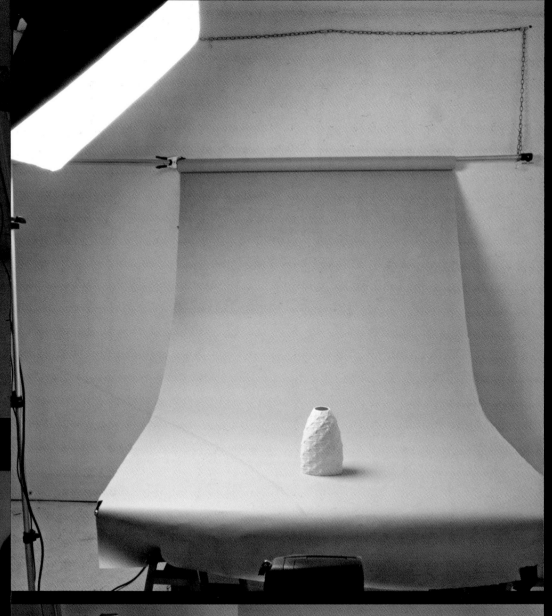

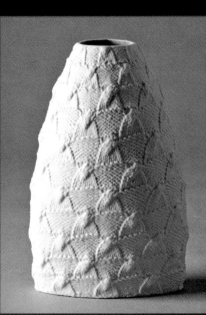

The light is moved to a higher side position.

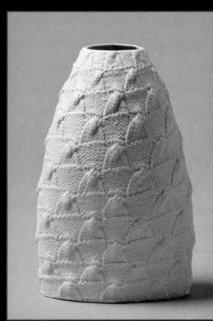

The light is placed at a low angle.

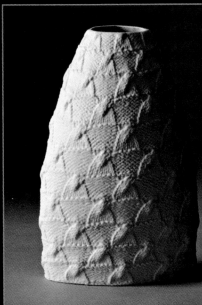

A reflector is placed to block the light falling onto the backdrop thus creating a shadow and darkening the backdrop. A second black reflector is placed at the side of the object.

Controlling the light on the backdrop

Try darkening the backdrop by blocking off the light falling onto it.

To soften the light from a light source you can either bounce it by pointing the light onto a white wall, ceiling, or a reflector.

A *photo umbrella* can also be used to soften the light, either by bouncing the light into the umbrella or by using the light passing through the translucent fabric of the umbrella.

A *softbox* is a nylon box with translucent material at the front which diffuses the light passing through it. The inside of the box has silver or white walls to reflect light. Softboxes attach to studio lights. Make sure you get one which is storable.

Light tents come in many sizes and varieties and can usually be folded for storage. They are made of white translucent material that diffuses the light placed outside the tent. The object is placed inside the tent. Make sure you get a tent which is large enough to be able to move the object around inside and which has sufficient space for placing small reflectors. Light tents are often used when photographing objects with reflective surfaces, such as silver, as the walls of the tent block reflections from around the room.

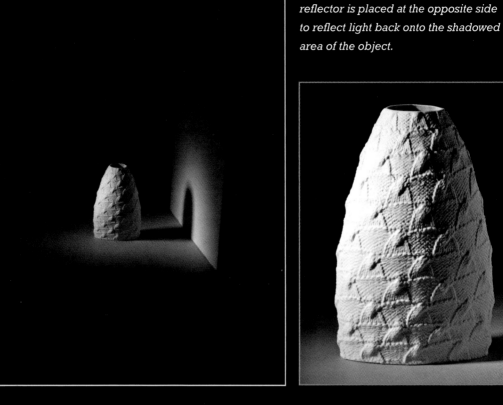

A spotlight (hard light) is directed onto the side of the object and a white reflector is placed at the opposite side to reflect light back onto the shadowed area of the object.

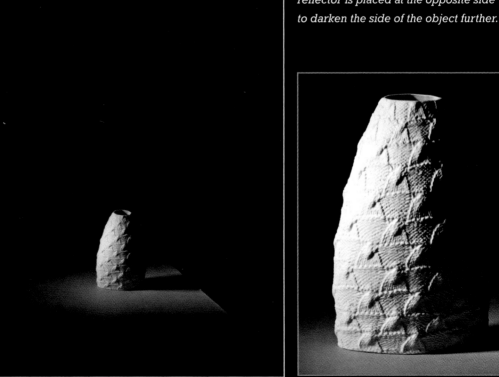

A spotlight (hard light) is directed onto the side of the object, and a black reflector is placed at the opposite side to darken the side of the object further.

Using more than one lamp

Working with more than one light source can be useful in many ways: creating backlight, or lighting the shadowed area to 'fill in' the shadows, or using a second light on the background, lighting it separately from the object. Regulate the power of the lights to create the effect you want.

NATURAL LIGHT

Before the invention of studio light, the first photographic studios used only natural light, like painters and other artists. The windows would be north-facing, creating diffused, soft light, with the light controlled by curtains, blinds and reflectors. The photographer would use a tripod to prevent camera shake, as long exposures were needed. When a sitter had his portrait taken, he would have to sit very still, sometimes with the help of a neck support.

Many photographers in different areas of photography still prefer working with natural light. Although it's not as easy to control as studio light, it is possible to get good results photographing your work using natural light and some reflectors.

SLR cameras, if used with a tripod and cable release, are able to work in very low light with good results using very long exposures.

Taking pictures using natural light

The light from a window will be diffused and soft, very similar to the light from a softbox (see p.46). Block out all other light sources and place your object on a backdrop, with the window light coming from the side. Control the light with reflectors as you would with studio light. Use reflectors to bounce the window light back onto your object, or darken shadows on one side of the object by blocking the light with a black reflector. Also, try darkening or creating shadows on the backdrop. If you want to soften the light further, you could hang white sheer fabric (or diffuser fabric bought from a photographic suppliers) in front of the window.

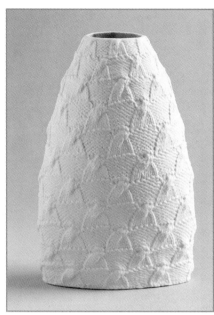

The object is placed so that the light from the window is illuminating the object from one side and a white reflector is reflecting light back onto the shadowed area.

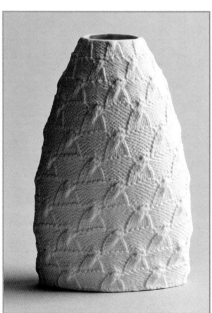

The object is placed so that the light from the window is illuminating the object from one side and a black reflector is placed at the opposite side, thus blocking any light and creating a darker shadow on the side of the object.

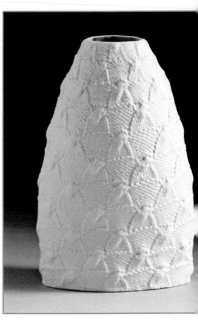

A reflector is placed to block any light from the window falling on the backdrop, thereby creating a shadow, making a darker tone in the backdrop. A second white reflector is placed to the side of the object.

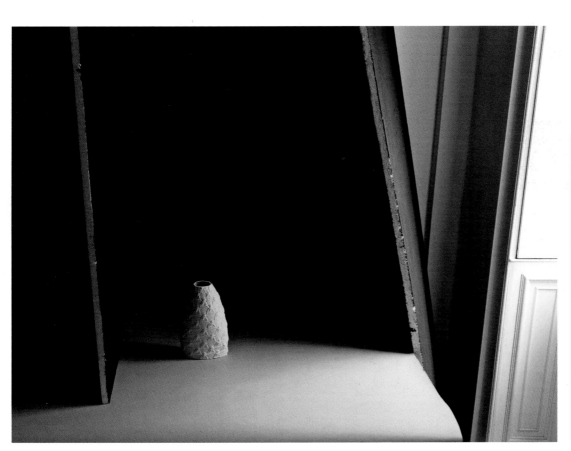

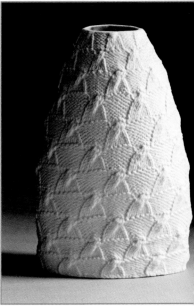

A reflector is placed to block the window light from falling onto the backdrop, creating a shadow thus making a darker tone in the backdrop. A second bl. reflector is placed at the side of the object.

The piece in all the above images is: Annette Buganski, Slub Vase, 2003. Porcelain, transparent glaze inside only. Height: 21cm (53in).

If you want hard light with more contrast, place your object in direct sunlight and use the reflectors in the same way, but be aware that the sun's motion means the direction of the light will gradually change.

Remember, the light will be less powerful and less controllable than that of studio lighting equipment, so your exposures will be longer and you will need a cable release and a tripod. If your floor has a bit of movement (as floorboards often have), then stand absolutely still to make sure the tripod doesn't shake. You can also use the Mirror Up (or Mirror Lock-up) position found on some digital cameras; this setting prevents the camera shaking when using long exposures as the mirror is flipped up before the shutter opens, allowing vibrations from the movement of the mirror to die down.

The brightness of light from a window won't be consistent but will change with the time of day and when clouds move in front of the sun, so always take a light reading just before you take your photograph. The colour temperature of natural light will also vary throughout the day.

STUDIO LIGHT

There are two types of studio light: continuous light and flash light. Both types are used with different light-modifying accessories such as diffusers, softboxes, reflectors and spot attachments, for different effects.

There are many makes of studio flash and continuous light but, when buying studio lights, look for a popular brand as this will make it easier to find good-quality light-modifying accessories. Also bear in mind that some cheaper lights have a fixed reflector which won't allow you to use interchangeable accessories, limiting your ability to control the quality of the light.

You can do a lot with just one light, using reflectors and keeping the lighting simple – one professional light with a light-shaping accessory of your choice might be all you need.

Continuous light

Some continuous lamps use tungsten bulbs, which have a 'warm' colour temperature. Tungsten lights are simple to use, but they can also get very hot and thus cannot be used with some light-shaping accessories. Be careful if using a tungsten light: don't place anything flammable against it and be careful not to burn yourself on the bulb or the metal case. Other continuous lamps use fluorescent, halogen or metal halide bulbs, which don't get as hot as tungsten bulbs.

Flash light

Studio flash light has two bulbs: a daylight-balanced flash bulb and a continuous-modelling bulb. The modelling bulb allows you to see what the light looks like whilst you're controlling and creating the lighting set-up, whilst the flash bulb is connected to the camera and gives a fast burst of light only when you press the shutter.

The flash duration is very fast (more than $1/1000^{th}$ second). This means that it will freeze any movement. You can work with a handheld camera using flash without getting camera shake. Any daylight spilling into the room won't read in your photos, as the flash will override it, but in any case you should always block out any accidental light so that you can only see the effect of your studio lighting.

To achieve your desired depth of field (f-stop) you can adjust the power/ brightness of the flash light, turning down the power for a shallow depth of field (opening up the lens), or turning up the power for a longer depth of field (closing down the lens).

When using flash, the camera shutter speed is set to a determined synch speed, usually marked on the camera, meaning the sensor or film is only exposed to light for the duration of the flash. You will need a separate light meter that is able to take flash readings.

There are two different types of flash studio light: monolight and pack-and-

head. Monolights have all the controls within the flash heads themselves and are powered directly from the mains electricity supply. Monoheads are the most popular with people starting out as they are less expensive than pack-and-heads. The pack-and-head system separates the light head and power supply and the controls are on the power pack rather than the lamp.

You can rent lights from some photographic suppliers, and this might be a good way to start. This will give you a chance to try different studio lights to get an idea of what you need. Tell the assistant in the hire department what you are using the light for, and let them know if you are unfamiliar with the lights so they can show you how they operate.

Colour temperature and white balance

We are surrounded by light with varying colour temperatures. Daylight has a higher colour temperature but a cooler (bluish) tint, and tungsten has a lower colour temperature but a warmer (reddish) tint. (Fluorescent light has an unpleasant greenish tint and is best avoided.) The unit of measurement for colour temperature is Kelvin.

Our eyes naturally adjust to the colour temperatures emitted by different light sources, so to our eyes white will appear white in any light; it will change in tone depending on the colour temperature, but our brains adjust for this so that our eyes always see white as pure white.

The AWB (automatic white balance) setting on digital cameras will use the sensors to calculate the white balance for your photograph. These calculations are often accurate, but if you get an unwanted colour cast in your photo, try setting the WB to match your chosen light (daylight, flash or tungsten).

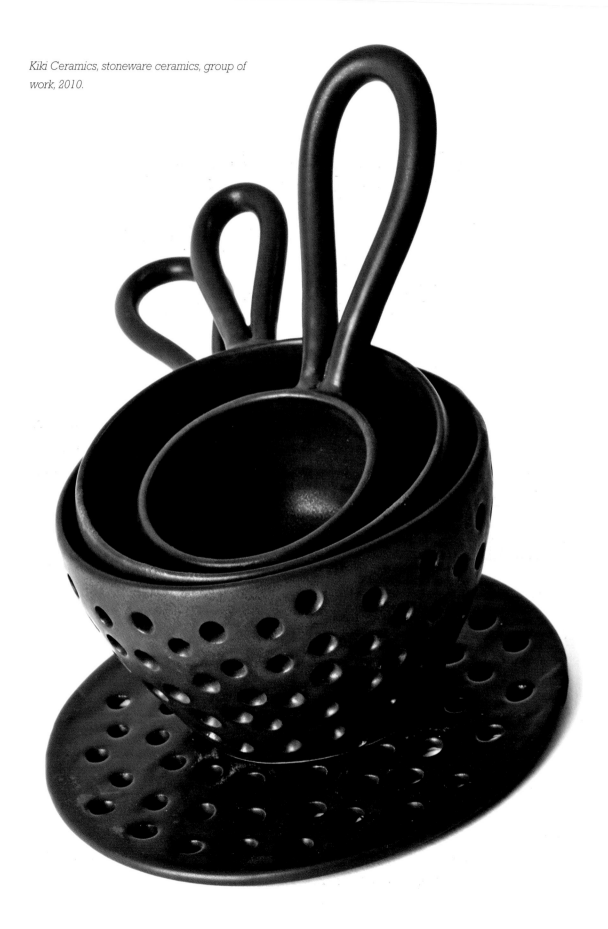

Kiki Ceramics, stoneware ceramics, group of work, 2010.

Composition, Viewpoint and Perspective

When first taking a picture it is common to place the object in the middle of the frame, but this doesn't always a make for an interesting composition, so take some time framing and composing your image. Try to create movement, a feeling of energy, beauty and interest in your composition. People often only see the object and not the negative space around it, so look carefully at everything within the frame – the object you are photographing as well as the empty space, shapes, highlights and shadows – and think about how they work together in a two-dimensional image.

Ask yourself the following questions:

How much space is there above and below the object?
Does this balance feel right?
Where is the viewpoint? Is it high or low?
What happens if you move the camera up or down, and how does this change the composition and perspective?

You will see that different viewpoints will also change the dynamics in the image. A low viewpoint may add more drama compared to the more common perspective of viewing an object from above.

top left
Throw

top right
(a

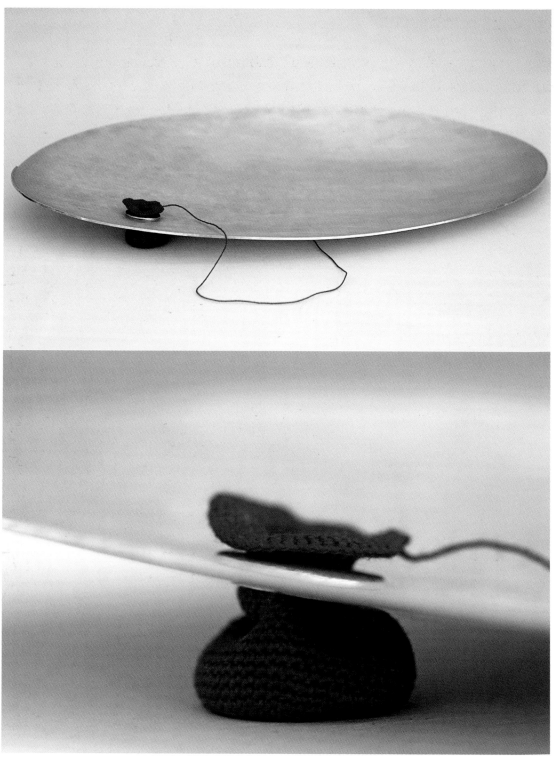

top: *Simone ten Hompel, Orange Abyss, 2008. Cotton and precious white metal. Diameter: 32cm (12½in).*
above: *Simone ten Hompel, Orange Abyss, 2008. The close-up image clearly shows the crochet cotton detail of the work.*

Groups of objects

When photographing a group, move the different objects around and play with the composition until it feels right. If you separate the objects at the back from those in the foreground, the perspective will change and the objects at the back will appear smaller. Moving the objects and changing the viewpoint will give you almost limitless possibilities, so enjoy playing with different compositions.

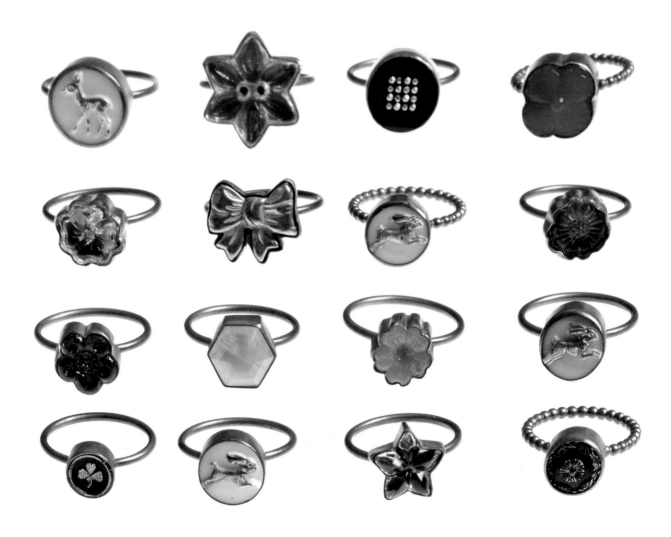

Grainne Morton, Vintage Rings, *2009. Oxidised silver, found objects. Rings arranged in neat lines.*

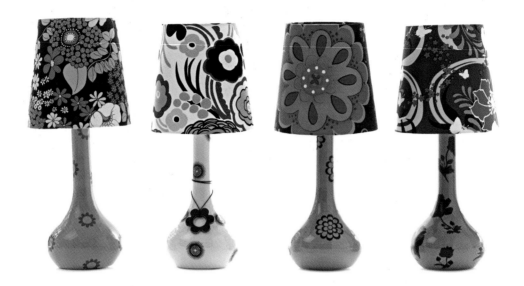

Flavia del Pra, Table Lamps Collection, *2007. Ceramic base and textile lampshades. Height: approx. 62cm (24½in) each lamp. Lamps arranged in a line for a clear product image.*

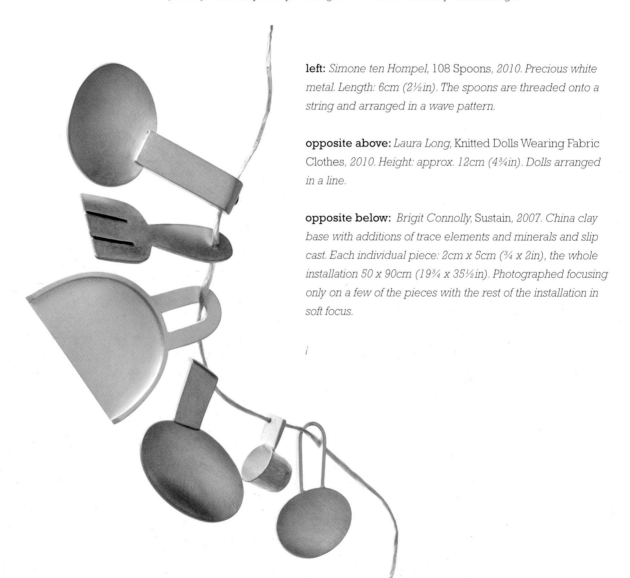

left: *Simone ten Hompel,* 108 Spoons, *2010. Precious white metal. Length: 6cm (2½in). The spoons are threaded onto a string and arranged in a wave pattern.*

opposite above: *Laura Long,* Knitted Dolls Wearing Fabric Clothes, *2010. Height: approx. 12cm (4¾in). Dolls arranged in a line.*

opposite below: *Brigit Connolly,* Sustain, *2007. China clay base with additions of trace elements and minerals and slip cast. Each individual piece: 2cm x 5cm (¾ x 2in), the whole installation 50 x 90cm (19¾ x 35⅓in). Photographed focusing only on a few of the pieces with the rest of the installation in soft focus.*

i

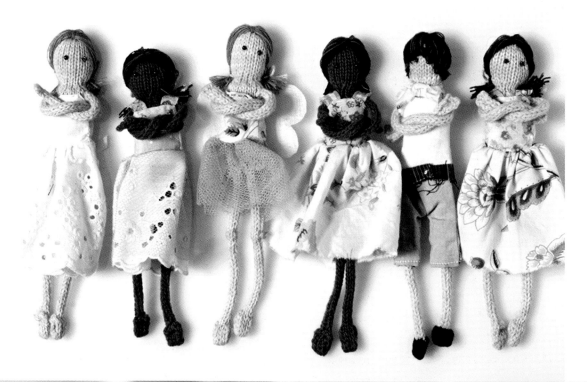

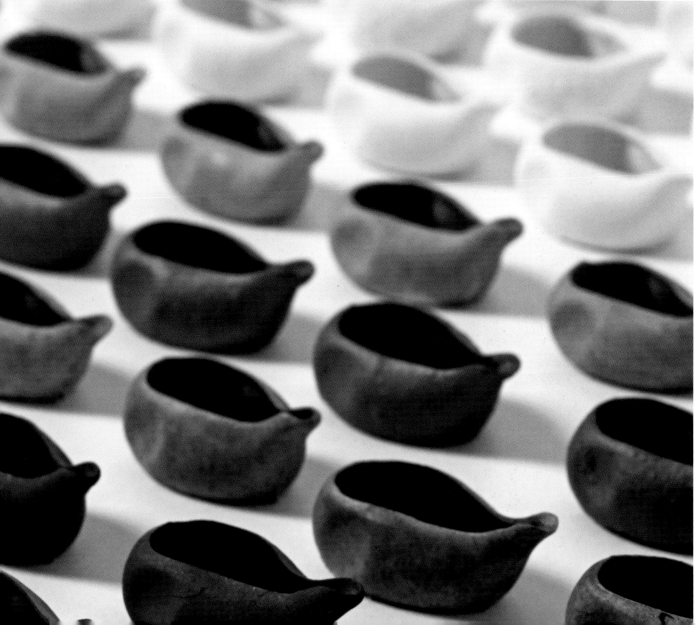

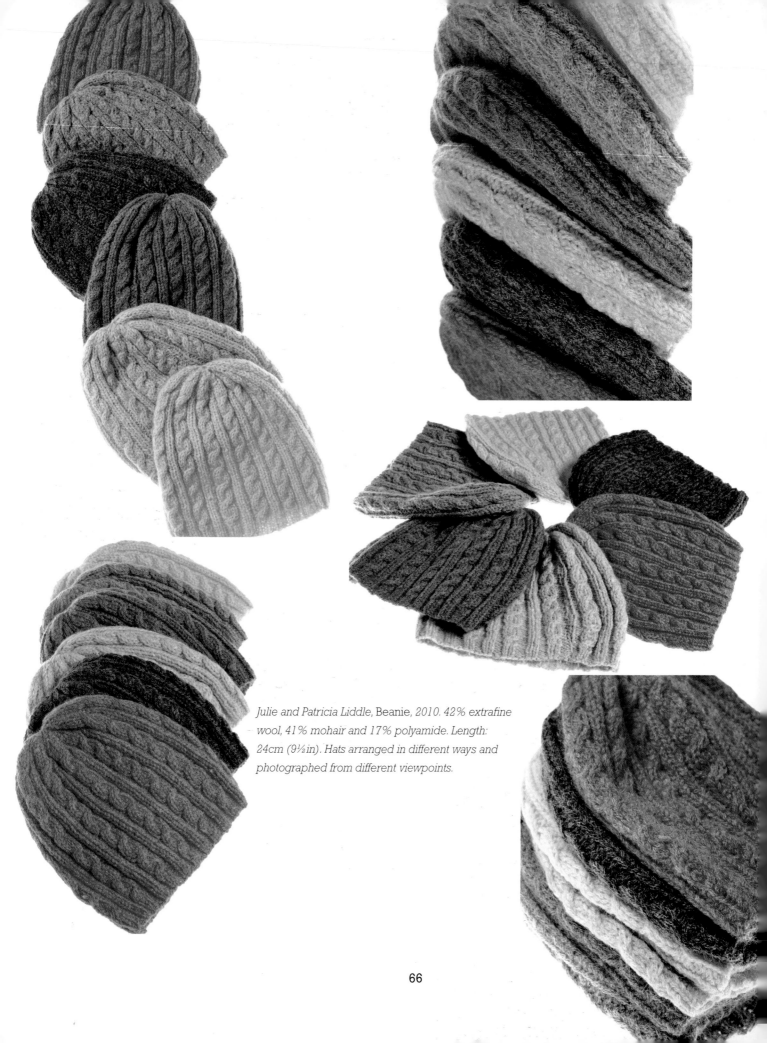

Julie and Patricia Liddle, Beanie, 2010. 42% extrafine wool, 41% mohair and 17% polyamide. Length: 24cm (9½in). Hats arranged in different ways and photographed from different viewpoints.

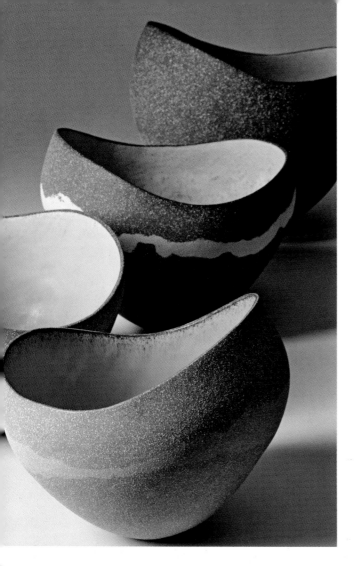

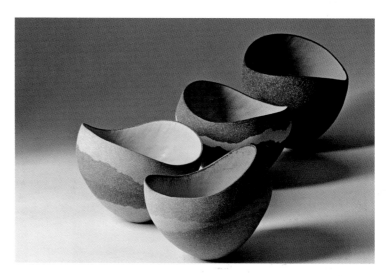

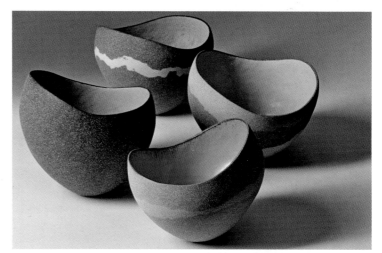

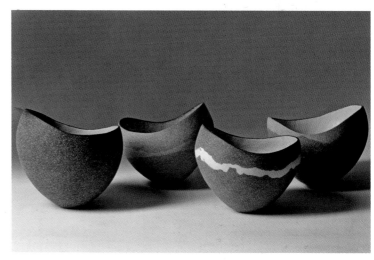

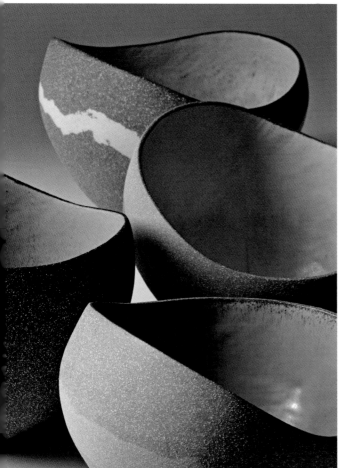

Kerry Hastings, Collection of Vessels, *2010. Ceramic. Approx. 15 x 16cm (6 x 6¼in). Arranged in different ways and photographed from different viewpoints.*

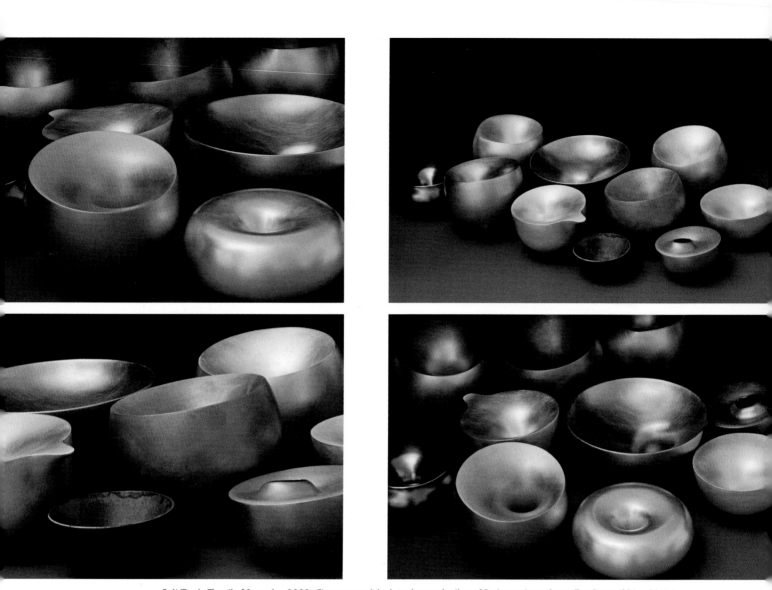

Adi Toch, Tactile Vessels, *2009. Copper, gold plated metal, silver. Various sizes: from 7 x 3cm (2¾ x 1¼in),
12 x 6cm (4¾ x 3½in) and 9 x 7cm (3½ x 2¾in). Arranged in different ways and photographed from
different viewpoints.*
opposite: *Yoyo Ceramic,* Tea Set. *Arranged in an informal way.*

Catherine Hammerton, Bottle Garden Muglet, 2010.
English creamware and print, 8 x 6cm (3 x 2½in). A group of mugs arranged in different ways on Perspex, lit
from below and photographed from different viewpoints.

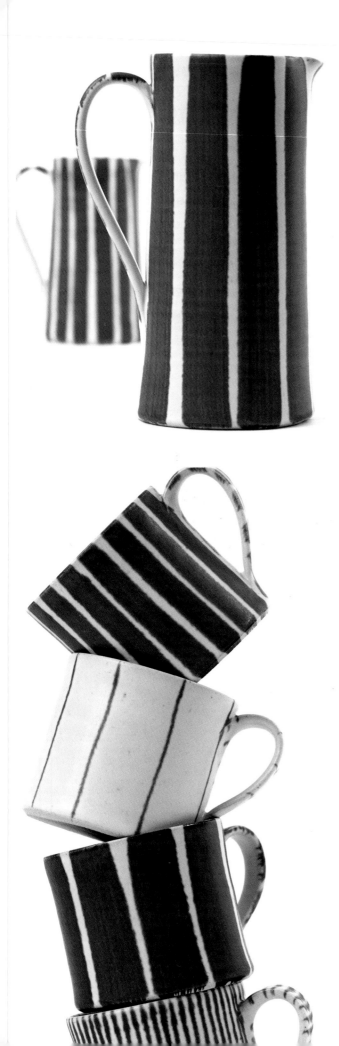

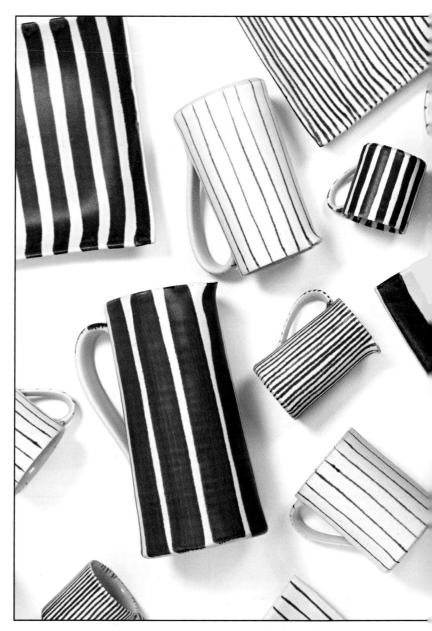

above left: *Sue Binns Pottery, Large Jug, 2010. Height: 19cm (7½in). Jugs placed with some distance between them.*

above: *Sue Binns Pottery, various pieces of ceramic work. Varying in size from 5–19cm (2– 7½in). Placed lying on white paper and photographed from above.*

left: *Sue Binns Pottery, Espresso Cups. Height: 5.5cm (2¼in). Stacked on top of each other.*

Backdrops

Setting your object against a backdrop can add drama, flattering, enhancing and isolating the object. Different backdrops will change the atmosphere, dynamics, style, mood and impact of the object.

Before choosing your backdrop, think of how your photos will be used. A gallery or jury will expect to see your work clearly photographed on a plain white or grey background. Your choice of background can be much more adventurous if you wish to create artistic, eye-catching and dynamic photographs for a website, card or brochure, or a display at trade shows. Keep in mind that the backdrop shouldn't dominate, but should complement your work.

Studio paper backdrops on a roll are available in many colours from most photographic suppliers, and are worth spending money on. A roll of paper will give you plenty of space for your set-up, and you'll be able to roll out the paper to make a seamless background.

Remember that you can create a darker shade in the background by blocking the light falling on it – this will give a feeling of depth to the images. You can also get purpose-made graduated backdrops that achieve this effect.

If you have a horizontal line in your set-up, make sure it is horizontal in your photograph, if necessary by using a spirit level on both set-up and camera. If your camera has a grid display pattern of horizontal and vertical lines, it will help you to get the horizontal line level. Some digital cameras have this option in the menu settings.

A black background can look very strong, making the object appear free-floating. Use non-reflective fabric like velvet or velour, as this will absorb the light and thus look very black.

opposite: *Jo Heckett,* Mini Easter Egg Magnets, *2010. Porcelain. Height: 3cm (1¼in) each. Arranged on a vintage plate.*

below left: *Simone ten Hompel,* Dose, *2010. Tin and alabaster, 8cm (3¼in). Placed on black velvet.*
below right: *Simone ten Hompel,* Untitled, *2010. Alabaster and precious white metal, 8cm (3¼in). Placed on black velvet.*

 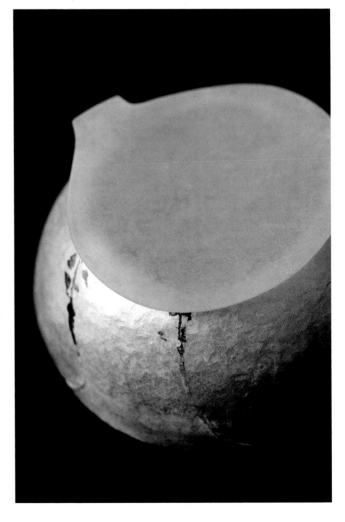

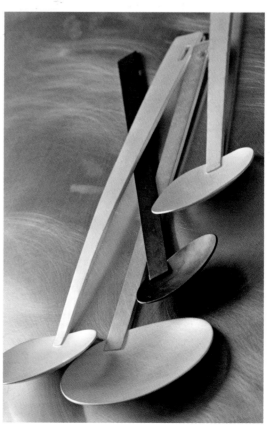

78

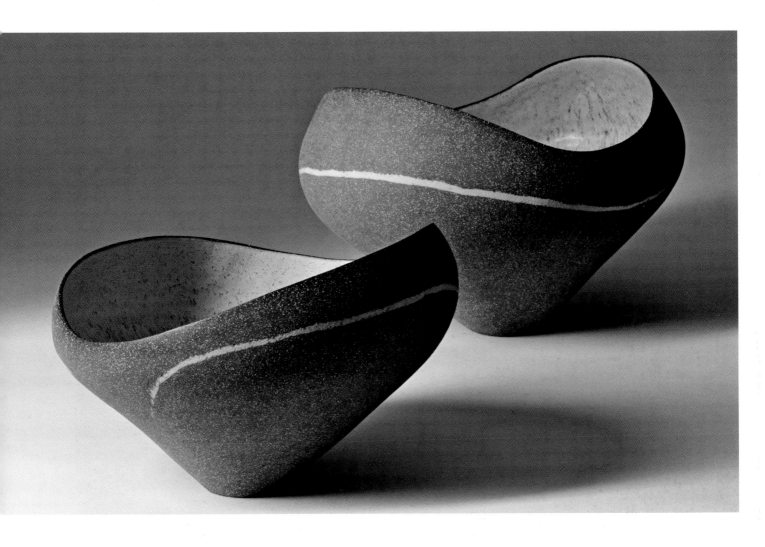

opposite:
above left: *Simone ten Hompel, 108 Spoons, 2010. Precious white metal. Length: max. 21cm (8¼in). Arranged on old floorboards.*

above right: *Simone ten Hompel, 108 Spoons, 2010. Mixed metal and wood, 16cm (6¼in). Arranged on leather.*

below left: *Simone ten Hompel, 108 Spoons, 2010. Mixed metal. Length: 14cm (5½in). Photographed on an old Persil box.*

below right: *Simone ten Hompel, 108 Spoons, 2010. Mixed metal. Length: 30cm (11¾in). Arranged on a sheet of aluminum.*

above: *Kerry Hastings, Chrome Green Bowls, 2010. Ceramic. Height: 19cm (7½in), width: 28cm (11in). Photographed on white backdrop paper with the light blocked from the background.*

Gina Cowen, Sea-Glass Necklace, *2001. Length: approx. 30cm (11¾in). The piece is placed in a tank of water with dark green backdrop paper placed underneath and photographed from above.*

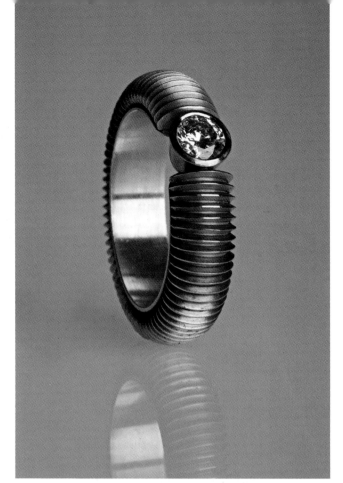

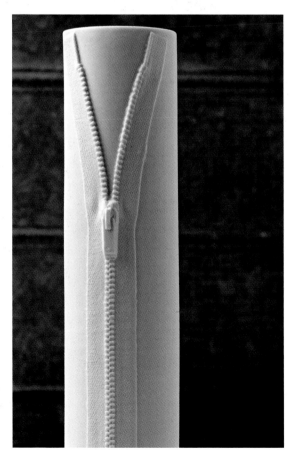

top left: *Steve Buck,* Hyperbolic, *2008. Blends of stoneware and red clay. Height: 34cm (13½in). Photographed on white backdrop paper with the light blocked from the background.*

top right: *Andrew Lamb,* Changing Colour, *2006. Ring series. 18ct yellow and white gold. Height: 25mm (⅛in). Photographed on Perspex.*

above left: *Angela Cork,* Waterline Vases, *2007. Sterling silver. 25 x 14.6 x 2.5cm (9¾ x 5¾ x 1in), and 32 x 19 x 3.3cm (12½ x 7½ x 1¼in). Photographed on white backdrop paper.*

right: *Annette Buganski,* Zip, *2007. Porcelain, transparent glaze inside only. Height: 20cm (8in), depth: 5.5cm (2¼in). Photographed with an old aluminium barrel in the background.*

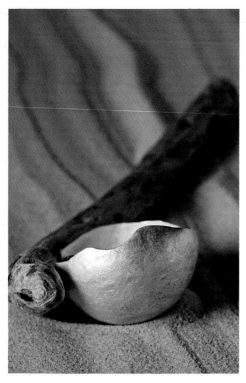

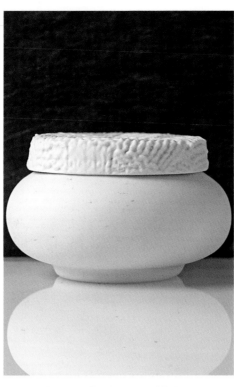

Louise Loder, Bowl on Stick, (part of Tools for Building Sandcastles No.7), 2006. Fine silver & driftwood. Height: 15cm (6in). Arranged on sand.

Annette Buganski, Trinket Box, 2007. Porcelain, glaze on inside only. Height: 6.5cm (2⅓in). Placed on Perspex with slate in the background.

Annette Buganski, Rib & Diamond T-light, 200 Porcelain, glaze on inside only. Height: 6.3cm (2⅓in). Arranged on mirror paper.

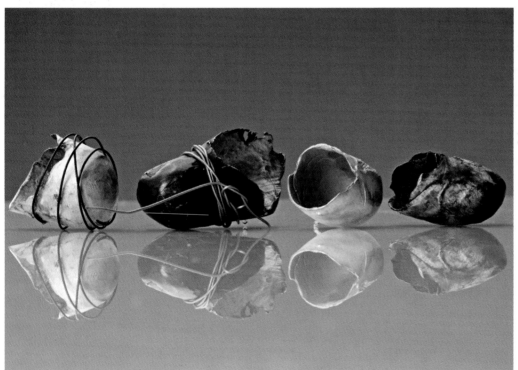

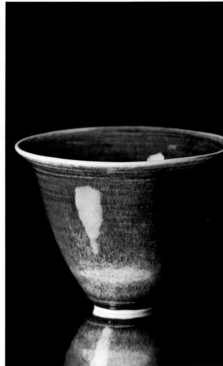

Jennie Hancox, Finger Print Brooch and Rings, 2009. Sterling silver oxidized and gold plate, 1.5 x 2.5cm (⁵/₈ x 1in). Photographed on perspex with grey backdrop paper in the background.

John Masterton, Upright Copper Red Bowl (Sang de Boeuf glaze), 201 Porcelain. Height: 14 cm (5½in). Placed on mirror paper with black velv in the background.

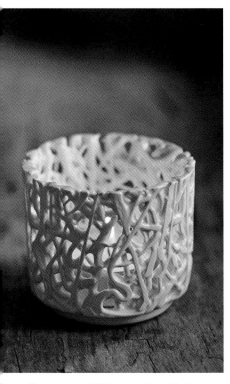

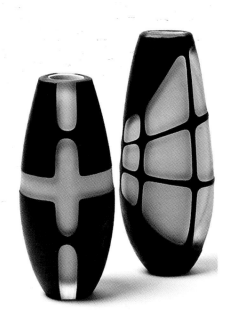

mea Sido, Tangled Web, *small tea light holder, 2009. White earthenware. Height: 5cm (2in). Photographed on an old wooden block.*

Anu Penttinen, Connect *(left),* Magnitude *(right), 2004. Hand-blown & diamond cut glass. Height approx. 22cm (8¾in) and 27cm (10½in). Photographed on white backdrop paper.*

Helen Johannessen for Yoyo Ceramics, Is that Plastic Too? Tea Set *(commission for With Associates) 2010. Glazed earthenware teapot, height: 25cm (9¾in); jug, height: 13cm (5in); cup, height: 7cm (2¾in). Photographed on white backlit Perspex to eliminate shadows, for a bright white background.*

If you have a small object, or you only need to photograph your work from above, then an A3 sheet of paper might be big enough.

Perspex or Plexiglas can be interesting to use as the opacity allows you to shine the light through the background from behind or below. This can be particularly useful when photographing translucent objects.

You can eliminate shadows from your object, making it appear free-floating (as well as making a very bright white backdrop), by making the backlight behind the Perspex brighter than the main light illuminating your object.

You can also achieve a mirror effect using perspex or Plexiglas, or other reflective surfaces such as mirror paper glass or a sheet metal.

If you want to add texture the options are endless, so look around and see what you can find to bring into your studio set-up: slate, wood, fabric, stone – anything that will complement the work and add texture, colour and interest.

Always look closely at the backdrop and remove any unwanted marks, dust or creases in fabrics, as every little thing will show up clearly in the picture.

opposite:
Simone ten Hompel, 108 Spoons, 2010. Precious white metal.
Length: 12cm (4¾in).
Photographed using different backdrops from the same viewpoint.

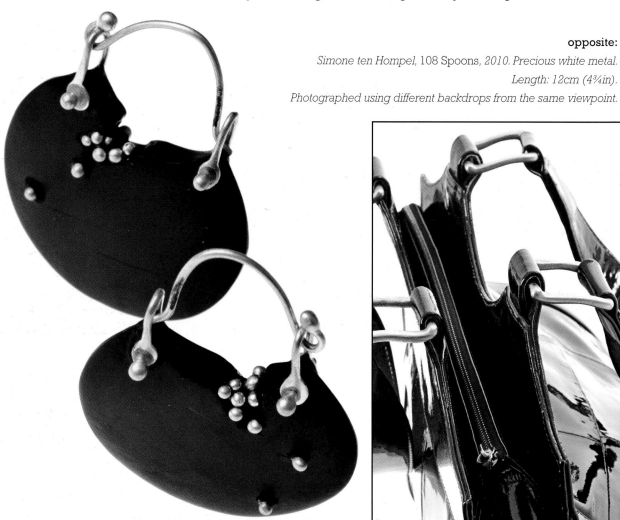

above: *Jacqueline Cullen, Carved Whitby Jet Earrings, 2010. With 18ct gold granulation, Whitby jet, 18ct gold. Diameter: 3cm (1¼in).*
Photographed on white backlit Perspex to eliminate shadows.

right: *Carmen Woods collection, Silverbell Slouchy, 2009. Black patent Italian leather.*
Height: 30cm (11¾in). Photographed on white backdrop paper.

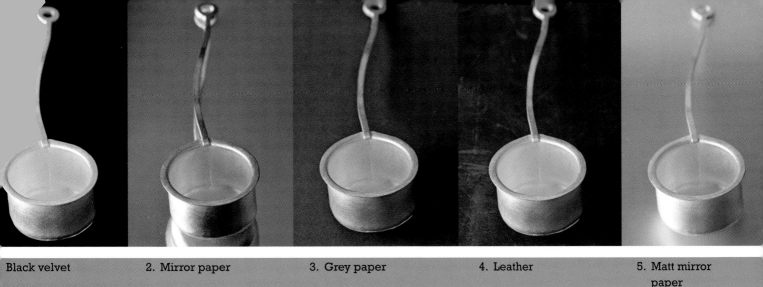

Black velvet 2. Mirror paper 3. Grey paper 4. Leather 5. Matt mirror paper

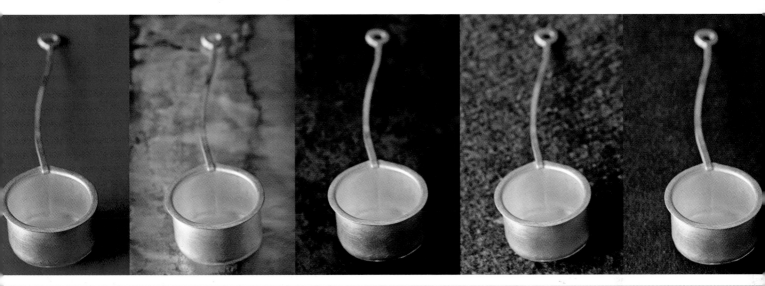

lue plastic heet 7. Stained foil 8. Rusty metal sheet 9. Wool fabric 10. Charcoal grey card

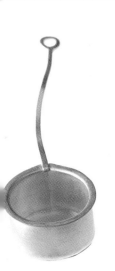
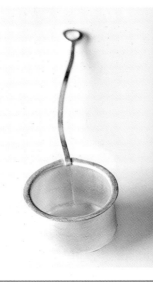
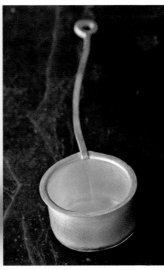
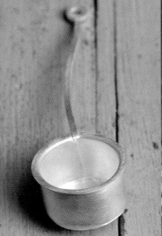
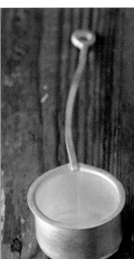

11. Backlit Perspex 12. White paper 13. Slate 14. Painted wood 15. Wood

Setting up a Studio

It's easy to turn your home, workspace or another location into a temporary photographic studio.

The basic set-up

- Depending on the size of your work, but even when photographing small work, a large clear space is best. You need enough room to separate the object from the background and to move the camera away from the object. You also need to be able to move your lights around and away from your object with ease. For average-sized work you'll need a space no smaller than 3 x 4m (10 x 13ft); for jewellery you can manage in a smaller space; and for models or large objects you will need a minimum of about 4 x 6m (13 x 19ft). A high ceiling is useful if you want to light from a higher angle.

- A stable, solid table of a comfortable working height, large enough to accommodate your work whilst leaving space around it.
- Backdrops of your choice.
- Light with light-shaping accessories for studio lamps.
- Reflectors: These can be white and black cards. Polystyrene boards, painted black on one side, are lightweight and won't cause breakage if they fall onto your work. You can also buy different-sized reflectors from photographic suppliers in black or white, as well as silver and gold, for different light effects. Kitchen foil also makes good cheap silver reflectors.

- A film or digital SLR camera.
- Lens with lens hood.
- Memory card or film.
- A sturdy tripod with the correct attachment for your camera, which is able to extend to the height you need. A tripod will prevent your images from becoming blurred due to camera shake, and will help keep your composition from shifting when you press the shutter, especially in close-up, where even tiny movements can alter the composition and focus point.
- Cable release, if you are using long exposures.
- Light meter, either the one in your camera or a handheld meter.
- A grey exposure card.
- A stable ladder in case you need a high viewpoint.
- Other props and tools including a spirit level, a colour card, clamps, Blu-Tack, tape and a compressed air duster.
- A notebook for taking notes as you go along, to avoid making the same mistake twice and to help you remember how you did something that worked well. Whilst setting up, record your lighting set-up, f-stop and shutter speed, the focal length of the lens and anything else you need to remember.
- Computer for storing and processing (and Photoshop if needed).

Getting started

Set up a table and backdrop in a position that gives you easy access, allows sufficient space for your lighting set-up and allows you to alter the distance between object and background.

Black out the window light to see clearly the effect of the studio light(s). If you are using natural light set up the table as on p.48 and switch off any lamps in the room.

When taking photographs in a studio setting, it's important to have the camera directly in front of the tabletop and background. Always work from this frontal position, moving only your object and lights. The camera should only move backwards, forwards, up and down, on the tripod.

Set up your lights. Place your camera on the tripod in front of the table.

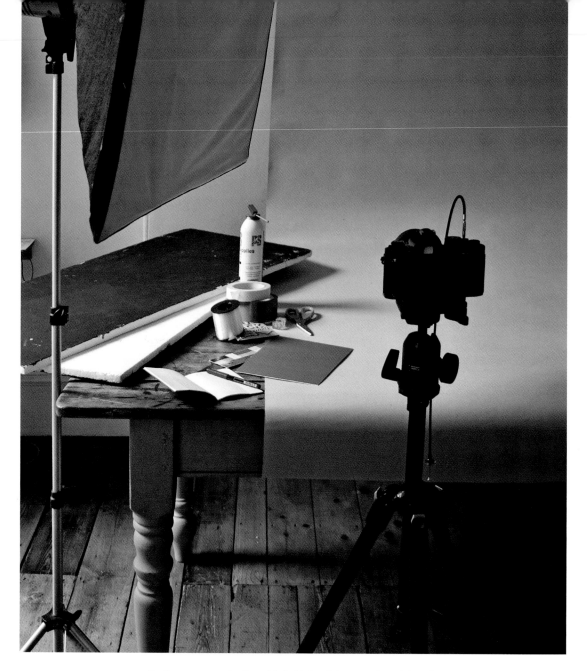

Setting up your studio, with light, backdrop and useful tools.

Once you have selected your backdrop, place your object against it and, looking at it from the front, move it around to find a good angle and composition. Move the light around, using the reflectors to reflect and block off light, until you're happy with the way the light is falling on both your object and the background.

Take a light reading, decide what depth of field you'd like, then set the f-stop and shutter speed accordingly.

Look through the viewfinder and carefully compose the image, looking at both the object and the space around it. Then take your photo.

Photographing Your Work Outside

Using Natural Backgrounds, Light and Textures

Take a walk outside and look at the textures around you. If you look carefully with the idea of creating an interesting image in mind, you'll discover many beautiful backdrops all around you, such as stones, sand, old textured wood, metals, concrete, pebbles, different coloured walls, dark green moss, glass, black tarmac, water, grass, bark on trees …

Put your camera on a tripod and try creating images using different backgrounds. Experiment by varying the depth of field, and use reflectors to control the light, creating shadows or reflecting light onto your object.

If you're shooting in direct sunlight, you'll get high-contrast images with hard shadows. If you work on a cloudy day, or in the shade, the light will be softer.

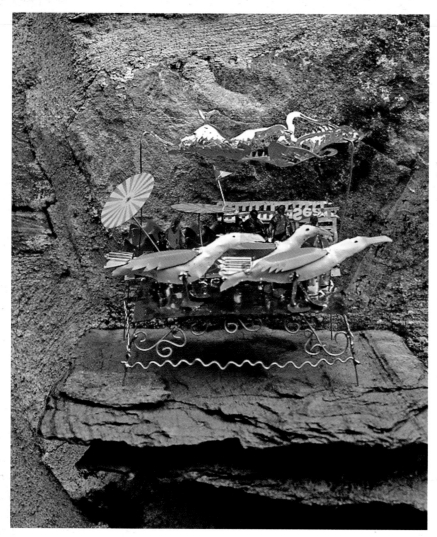

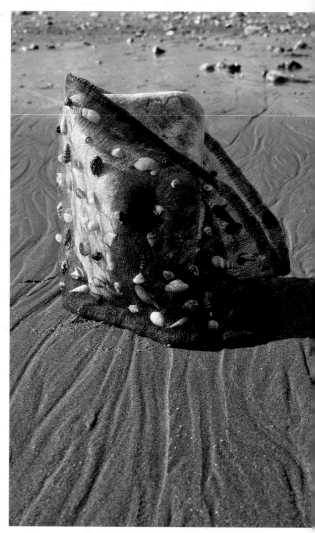

above left: *Lucy Casson, Sea Gulls, 1990. Tin and wire automata. Height: 20cm (8in). Photographed outside surrounded by stone and slate.*
above right: *Susie Freeman, Shells Neck Cowl, 1986. Pocket knitted nylon mono-filament, shells, pebbles and polished stones. Height: 20cm (8in). Photographed on a beach to complement the decorations on the cowl.*
right: *Lucy Casson, Crow, 1989. Tin automata. Height: 13cm (5in). The setting for this makes the crow look animated and the red apple complements the red in the piece.*

opposite: *Ann Carrington, Tin Can Fishes, 1992. Tins, cans, old forks, spoons and old purses. Height: approx. 40cm (15¾in). Hanging from a hook on a harbour wall as if they have been caught from the sea.*

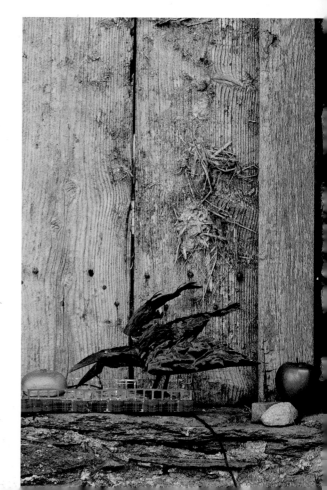

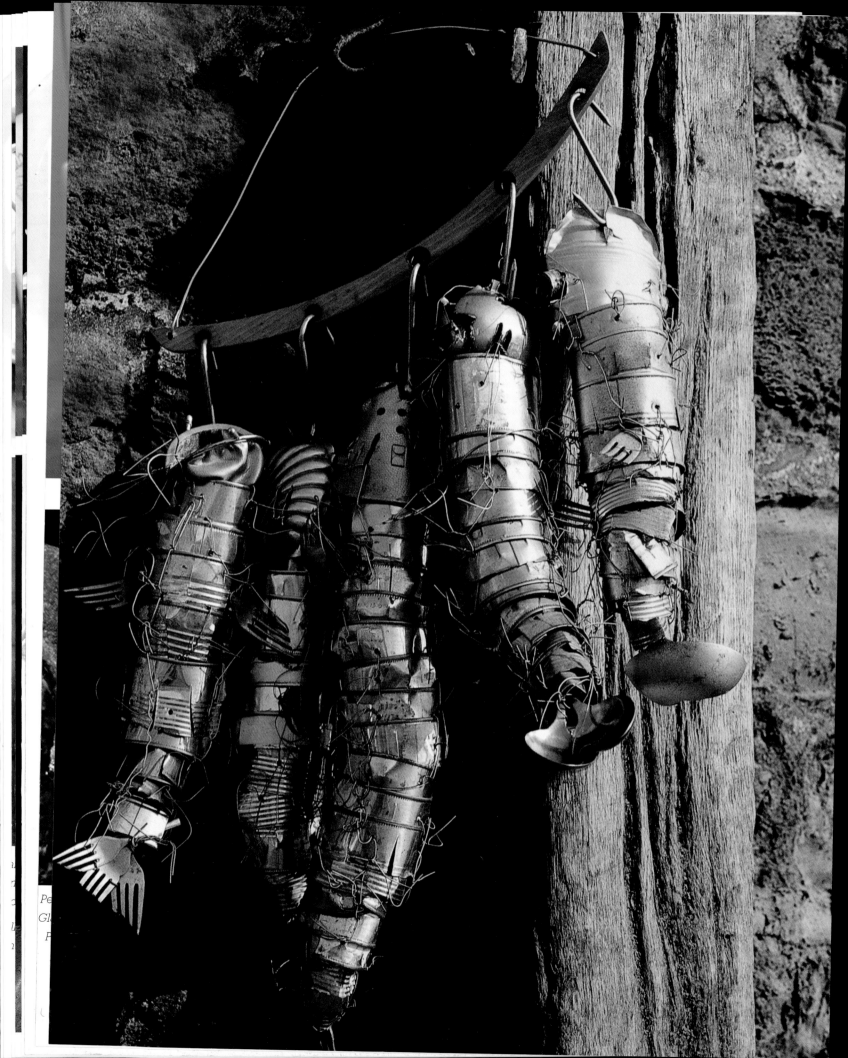

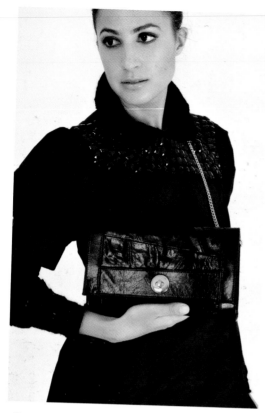

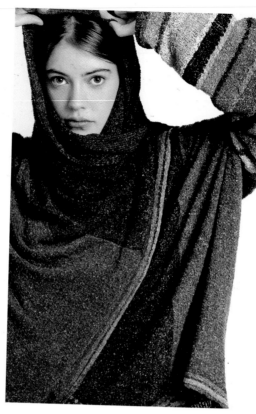

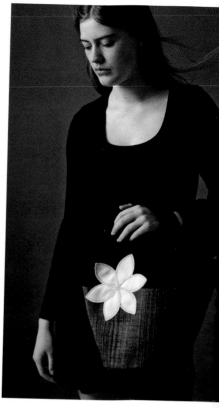

Carmen Woods collection, The Papaver Clutch in Black, 2010. Italian leather. Height: 16cm (6¼in). For emphasis the bag is placed in the centre of the photo and the model is cropped.

Alison Dupernex, Large Collar Coat in Silk Marl, knitted and designed in 2007. Photographed with a white backdrop for a fresh, bright look.

Angela Kerkhoff, Bucket Bag, 2008. Appliqué, wool. Height: 38cm (15in). Photographed on a model wearing dark clothes against a dark background to emphasise the light appliqué on the bag.

If you are working with natural light remember that an exposure of slower than 1/60th of a second will cause movement blur if your model is moving. Flash studio lights are often used for fashion photography as they release a fast burst of light that freezes any movements.

Remember when lighting your model to look at the light falling on the model's face and clothes as well as on the background. Use reflectors to reflect light back or create shadows in the same way as shown in the chapter about lighting. If you are using studio light, you can light the background and model separately.

Sometimes props can enhance an image and give the model something with which they can interact. The most confident person can feel intimidated in front of the camera, sometimes causing their face to become rigid or their body to be

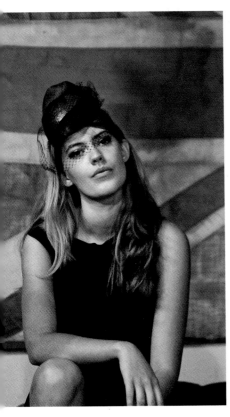

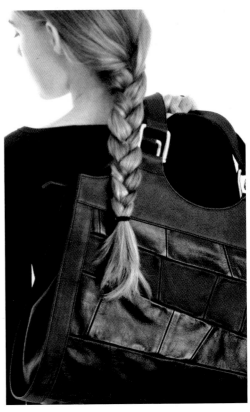

Karen Henriksen, Italia, from 'Soho' Couture Collection. Sinamay with suede trim & silk vintage veil. A/W 2010-11. Model: Ester Keate. Photographed in low ambient light with the model sitting very still to avoid movement blur. The model looks directly into the camera with confidence.

Linda Dooley, Silver Wrap Around Collar, chunky knit, 2009. Silk/linen mix and silk/viscose velvet. Length: 68.5cm (26½in). The model looks away from the camera to draw attention to details in the knitwear.

Carmen Woods collection, The Linden Slouchy In Mixed Shades of Black, 2008. Italian leather. Height: 41cm (16in). Photographed with the model carrying the bag on her back – the attention is on the bag and the model is hardly seen.

held in an awkward way, so try to make your model feel confident and they will relax as you go along. Give positive encouragement but not too many directions – try instead to have fun. Demonstrating to models how to move or sit in different poses can make them feel less self-conscious.

Some models like to have a mirror so that they can see what they look like in different poses (though other models will hate that). Sometimes showing the model the pictures on the LCD screen of a digital camera, or via a computer connection, can help give an idea of what the photos look like and what you're trying to achieve.

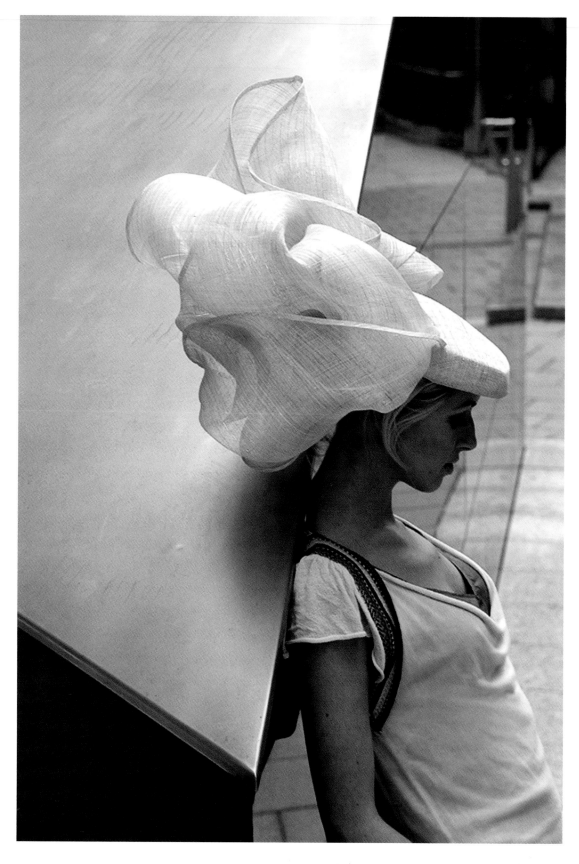

Karen Henriksen, Sinamay Cloud Hat *from 'Elemental' Couture Collection. Sinamay. S/S 2007. Model: Jennifer Chapman. Photographed in a city setting. The angular shapes of the architecture contrast with the soft shapes of the hat.*

Movements can add to the composition and attitude of your photo. Encourage your model to move – walk, run, jump, dance – anything to just get them moving, but you will need to use a long depth of field, as it's difficult to accurately re-focus when the model is moving.

Using a wind machine (or your assistant fanning the model with a large piece of cardboard) will also add movement to the image. If you want stillness and seriousness in your picture, then a model holding a confident pose with an interesting look on their face can look moody, intense and beautiful.

Some post-production will need to be done on fashion-shoot images, sometimes just to brighten eyes or remove unwanted marks on the skin.

It's advisable for you and the model to sign a model release form, this gives you the right to use the pictures, making sure that you do not get sued for releasing them, or have any problems later. You can download a model release form from the internet.

Working with models on location

Finding a location that's interesting and suitable for your work will need some planning. Of course, many lovely (but expensive to hire) interiors and exteriors can be found via the internet, but with some imagination you can also find interesting locations. However, it's a good idea to check beforehand if you need permission to use them.

You might be limited by how far you wish to travel, but photos shot on a beach, in a city setting, in the countryside will all create different moods, so you might want to ask yourself the following questions:

In what settings do you imagine the clothes being worn?
Who will wear the garments?
What feeling do you wish to evoke with the image?
What do you want your work to express?
Once you've found an interesting location and a suitable model, and have an

Prilly Wear, Knitted 100% Lamb's Wool Coat, *2007. The warm woollen garment is photographed on a model walking in a winter forest with complementary surrounding colours. A long lens is used set on a shallow depth of field to give the background a softer focus.*

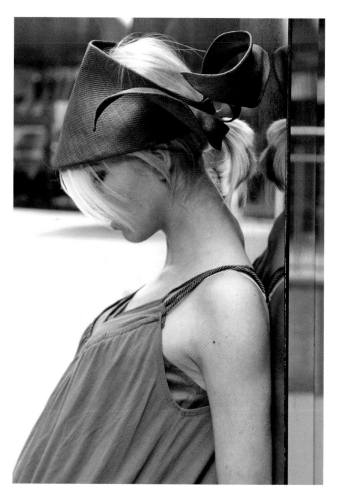

Karen Henriksen, Sculpted Straw Hat, *from 'Elemental' Couture Collection. Pari-sisal straw. S/S 2007. Model: Jennifer Chapman. Photographed in a city setting. The neutral tones of the location emphasise the colour of the hat. The photo is taken with a long lens set on shallow depth of field to soften the background.*

idea of the type of images you want, plan the shoot carefully. Decide upon which lens to use and the depth of field. Using a shallow depth of field, focusing on the model, will bring attention to the clothes and model and give less attention to the surrounding space, leaving only a general sense of the surroundings. However, you might want to have the surroundings of your chosen location all in sharp focus.

If you are working in an interior with limited natural light I would suggest putting your camera on a tripod, using longer exposures and taking photos of the model sitting or standing still. Otherwise you will need to bring studio lights. Take the light readings off your model as that's where you want accurate exposure.

If the natural light is very low, one option is to change the ISO setting on the camera (or if you are working on film, use a higher ISO film speed). This will lessen the quality of your image but may be necessary to avoid movement blur.

Using different lenses will produce images with very different perspectives. If you are not sure about what will work best, do some test shots in advance, trying lenses with different focal lengths, and different f-stops, and looking at the results when planning the shot. Take inspiration from images you like: look closely at the composition, the pose of the model, the light and the depth of field.

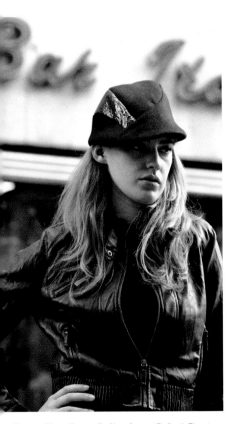 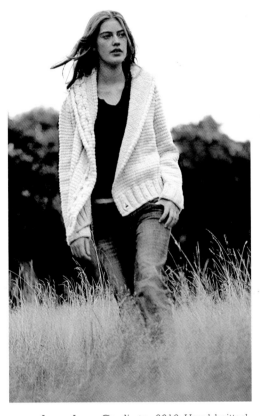 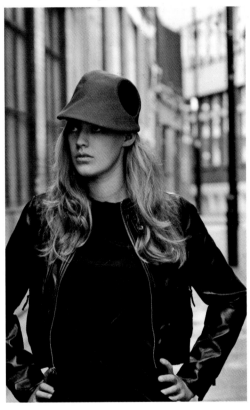

Karen Henriksen, Italia, from 'Soho' Couture Collection. A/W 2010-11. Sinamay with suede trim & silk vintage veil. Model: Ester Keate. Photographed in an urban setting and shot from a low viewpoint. The photo is composed so that the hat has a lighter and less busy background to make it stand out in the photo.

Laura Long, Cardigan, 2010. Hand-knitted Italian wool. Photographed in a country setting with the surrounding colours complementing the knitwear. A long lens is used with a shallow depth of field to soften the foreground and background.

Karen Henriksen, Compton, from 'Soho' Windswept Collection, A/W 2010-11. Pure wool with patent leather detail. Model: Ester Keate. Photographed in an urban setting with the surrounding colours complementing the hat. The background is de-emphasised using a shallow depth of field.

Karen Henriksen, Stripe, from 'Soho' Windswept Collection. A/W2010-11. Pure wool with patent leather detail, The street market makes a contrast to the smartly dressed model. A long lens is used with a slightly shallow depth of field to soften the background.

KuSan Accessories, Himalayan style hand knitted hat, 2009. From 100% New Zealand wool. The focus is on the hat with the model facing away from the camera.

Inverni S.r.l, Fair Isle Trilby, 2009. Knitted, baby alpaca wool. Photographed against a white textured back ground to emphasise the colour of the hat. The model is in direct sunlight with the hat shading the model's face.

far left: *This photograph is taken with the camera on a tripod. The shutter speed is set on 15th of a second with the model standing still.*

left: *This photograph is taken with the camera on a tripod. The shutter speed is set on 15th of a second with model moving - causing movement blur.*

Weather

Have a look at what the light is like on location at different times of the day. Do you want the high-contrast light and long shadows you get on a sunny morning or late afternoon? You don't need to shoot on a bright sunny day. In fact the soft light you get on an overcast day is lovely, won't cast hard shadows on the model's face, and won't make the model squint.

Rain can be a problem, as you probably don't want the model looking soaked, but if you can find an assistant to hold an umbrella over your model you might find you like the wet reflective surfaces that rain brings to the image. A windy day might provide great drama with movement to hair and clothes.

If you're working at a busy location, surrounded by people, make sure you've chosen a model who will remain confident. Perhaps find a time of day when there won't be too many passers-by (unless you want a lot of people in the background), but remember that people can strongly object to being photographed.

Be well-organised and well-equipped before you set off, and try to make it all fun. Do your creative thinking and planning beforehand so that you are well prepared once on location. Although there will still be time to be creative, the day of the shoot with a model is not the time to experiment. Being well prepared helps you engage and interact with the model and allows you to focus on getting the images you want.

If you have a budget for a make-up artist and stylist I would strongly recommend using them – apart from being experts in their work they are often helpful at seeing the little things that need correcting whilst you're behind the camera.

If possible, bring a friend or assistant to help reflect light onto your model (using white, silver or gold reflectors) and to look after belongings when you're busy behind the camera. Have food, drink and warm clothes ready; if changes of clothing are needed, plan beforehand exactly where these can take place. If you need movement on a still day, ask your assistant to create some wind by waving a large piece of cardboard or a reflector. If you need to shade the model from bright sunlight, bring a large reflector to place above him/her to create a shadow.

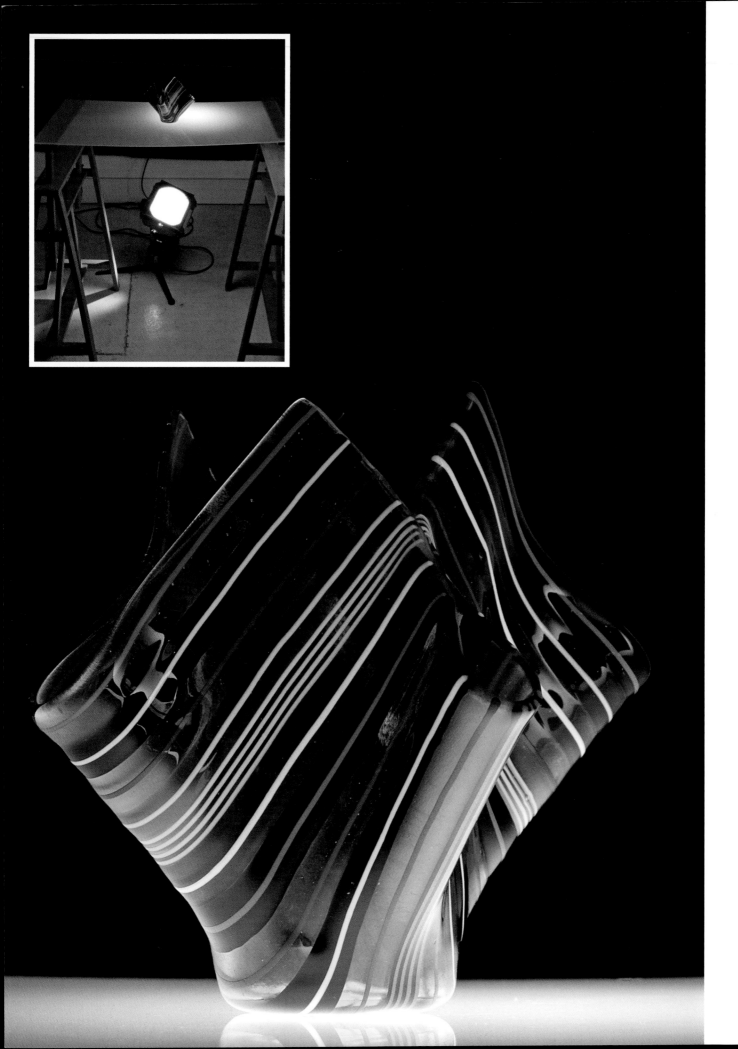

CHAPTER FOURTEEN

3D Work

Glass

Glass is translucent with a reflective surface, so needs specific lighting. This translucent quality of glass is best captured with backlighting, i.e. light directed through the glass. The reflective surface can be enhanced by a soft light directed from the front or side. Hard light on a reflective surface can create an unwanted bright spot or glare.

Here are some different ways of backlighting your object:

- Bounce the light off the background onto your object.
- Place the work on a piece of Perspex or Plexiglas and light it from underneath.
- The Perspex or Plexiglas can be placed behind the object with the light behind the Perspex.
- A spotlight can be directed through the glass.

opposite: *Aline Johnson*, Beach Striped Hanky Vase, *2010. Fused glass. Height: 17cm (43in).*

The glass is lit by one lamp only, placed underneath a sheet of Perspex, emphasising the translucency of the glass object.

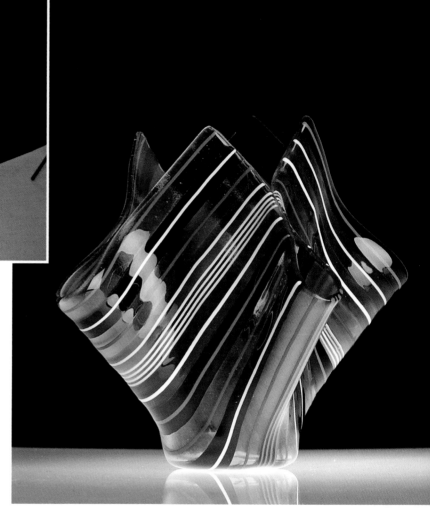

above and right: *A second lamp is added to light the surface of the object, emphasising its reflective quality.*

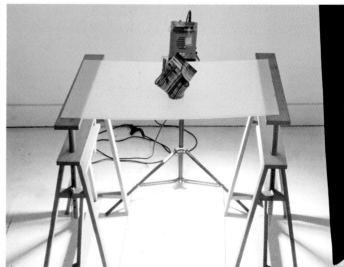

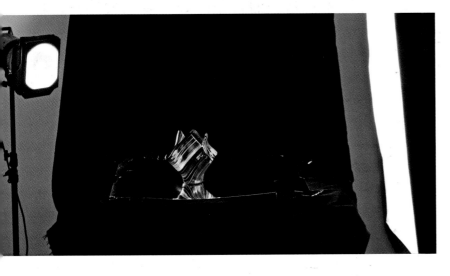

left: A spotlight is directed from a back/side position with the light shining through the glass, and a soft light is placed in a front/side position.

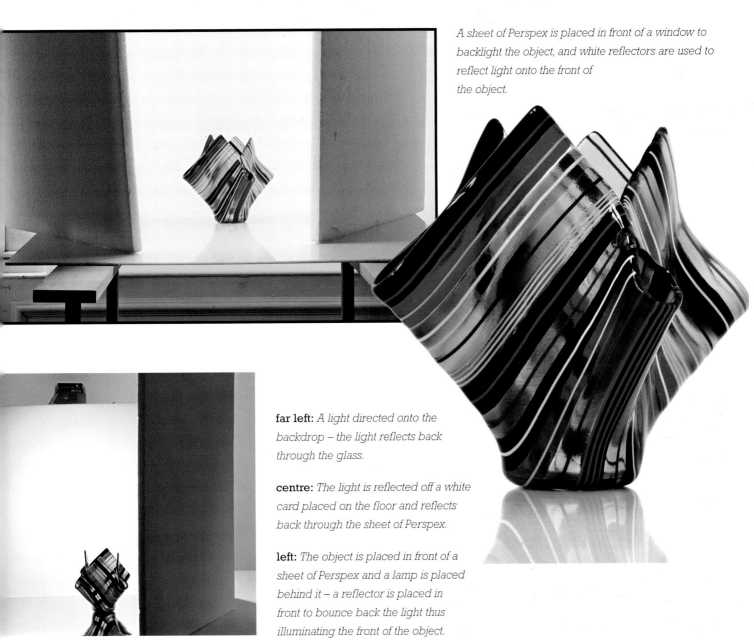

A sheet of Perspex is placed in front of a window to backlight the object, and white reflectors are used to reflect light onto the front of the object.

far left: *A light directed onto the backdrop – the light reflects back through the glass.*

centre: *The light is reflected off a white card placed on the floor and reflects back through the sheet of Perspex.*

left: *The object is placed in front of a sheet of Perspex and a lamp is placed behind it – a reflector is placed in front to bounce back the light thus illuminating the front of the object.*

right: *Melissa Simpson,* Red Bucket Bag, *2010. Vintage red leather edged in dark red and lined in cornflower suede, 30 x 27 x 11cm (11¾ x 10½ x 4¼in). Lit with one soft light directed from the side and a different light illuminates the backdrop to create a very clean white surrounding.*

far right: *Angela Kerkhoff,* Canoe, *2007. (Embroidered) Silk. Height: 17cm (6¾in). Arranged to create interesting shapes and lit using a studio light with a softbox attachment.*

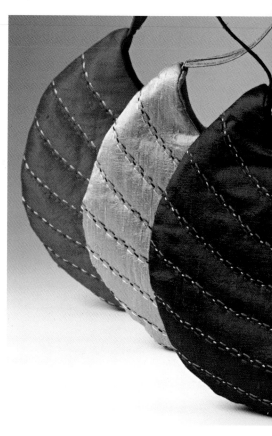

right: *Alison Dupernex, scarves knitted in silk marl, honeycomb design in purple and brown. Originally made in 2008. The scarves are arranged across the image to create a sense of movement in the composition.*

far right: *Angela Kerkhoff,* Bucket Bag, *2007. Embroidered cotton. Height: 38cm (15in). Photographed on a white background with the light flagged off the background to make the background a shade darker.*

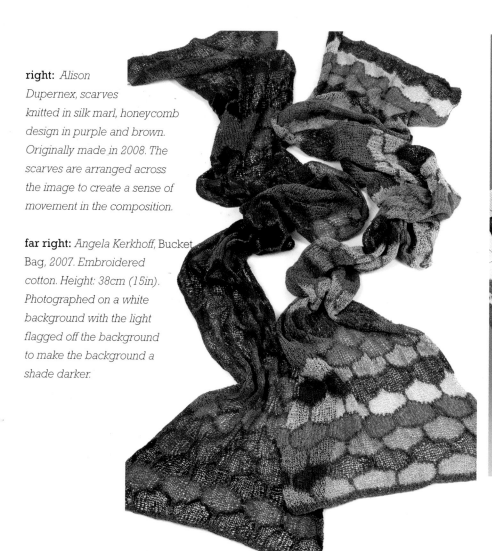

Fabric and Leather

The different qualities of fabric need to be captured in a way that gives the viewer a sense of what the fabric would feel like. Lighting can enhance delicate textures, translucency and the sheen of different fabrics.

The texture of fabric is enhanced by hard light and light directed at the fabric from a low angle.

You will be able to enhance the translucency of fabric such as silk with backlight in the same way as in the light set-up for glass.

Shiny surfaces in fabric such as silk or leather will need a soft light to avoid glare.

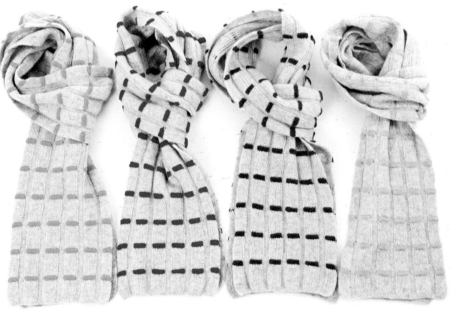

above right: *Annie Neil,* Tuck Scarf, *2010. 50% cotton, 50% wool. Length: 175cm (69in). Backlighting emphasises the fine texture of the knitting.*

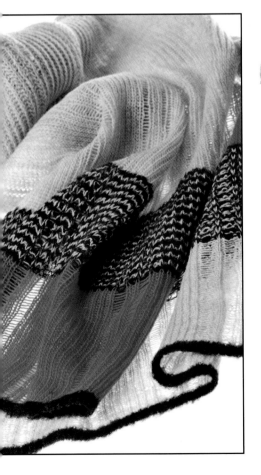

left: *Annie Neil,* Lattice Scarf, *2009. 100% lamb's wool border stripe, 70% extra-fine wool and 30% polyamide. Length:175cm (69in). Photographed on Perspex with backlight to emphasise the texture of the scarf.*

above: *Zoe Miller,* Code Scarves Collection, *2009. 100% knitted lamb's wool. Approx. 25 x 130cm (9¾ x 51in) each. Arranged to clearly show that they are scarves.*

119

Laura Long, Knitted Cushions, *2008. Approx. 50 x 40cm (19¾ x 15¾in). Photographed with soft light and a long depth of field to show the details in the design.*

Linda Dooley, Silver, Wrap Around Collar Chunky Knit, *2009. Silk/linen mix and silk/ viscose velvet. Length: 68.5cm (27in). The softbox attachment on a studio light is used to create a reflection on the velvet.*

Melissa Simpson, A4 Folded Bag, *2010. Tan cow leather. 32 x 26cm (12½ x 10¼in). Soft light and white reflectors are used to prevent glare.*

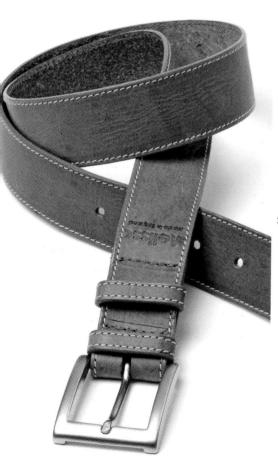

left: *Melissa Simpson,* Jean Belt, *2010. Vintage green leather edged in pink and yellow stitching, 90 x 3.5cm (35½ x 1½in). The belt is rolled up and arranged to make an interesting shape.*

right: *Kim Robertson,* Twiggy Buds Tie, *2007. Silk. The tie is arranged to create a sense of movement in the composition.*

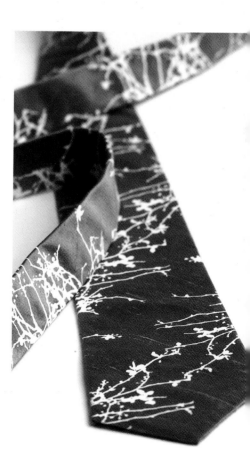

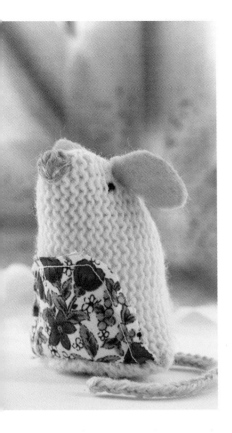

above left: *Laura Long, small knitted mouse. Height: 7cm (2¾in). Photographed with a flower in the background to illustrate the small size of the mouse and to complement the pink in the fabric.*

above centre: *Tamasyn Gambell*, Luxury Silk Scarf, *2009. Silk. 1.5m x 30cm (59 x 11¾in). The scarves are photographed floating in the air. Studio flash light is used to prevent movement blur. Light is bounced off the wall in the background to backlight the scarves, emphasising the translucency of the silk.*

above right: *Zoe Miller*, Striped Textured Purse, *2009. 100% knitted lamb's wool. Approx. 14 x 8cm (5½ x 3¼in). Photographed close-up showing the details of the buttons.*

left: *Zoe Miller*, Code Scarves Pink, *2009. 100% knitted lamb's wool. Approx. 25 x 130cm (10 x 51in). The scarves are photographed with soft light and a long depth of field.*

Silver and Other Metals

Silver, especially when polished, is not easy to photograph as it will reflect everything in the room just like a mirror. So you will have to control what can be seen in the reflections whilst checking through the viewfinder.

Block and replace the unwanted reflections you see in the piece by placing reflector boards around your object, using the reflectors to create grey, black or white reflections on the object.

To avoid reflections of yourself and the camera falling on the object, hide the camera and yourself behind a reflector with a hole for the lens.

The hard reflective surface of silver needs soft light to avoid glare and 'hotspots' (areas with no information). Use very soft light from softboxes and move the light away from your work, or bounce the light onto a white ceiling, reflector or wall.

A light tent can be useful for this sort of work as it will soften the light as well as stop reflections. You simply place the silver inside the tent with the lens of the

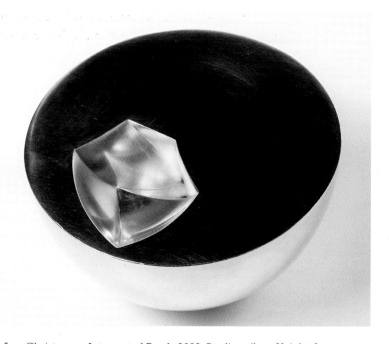

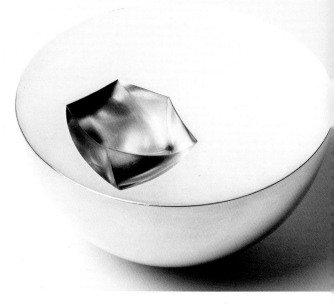

Ane Christensen, Introverted Bowl, *2009. Sterling silver. Height: 8cm (3¼in). A black reflector is placed above the object.*

Ane Christensen, Introverted Bowl, *2009. Sterling silver. A white reflector is placed above the object.*

122

camera through a hole, and control the light from outside the tent.

When you expose for silver, make some slightly darker exposures as well, as underexposure tends to be better for showing the qualities of silver.

Don't use dulling spray as this will make polished silver look like unpolished silver.

Unpolished silver is easier to photograph, but still keep the light very soft to avoid glare, and use white, black and grey reflectors to control the shade of the reflections.

The colour of the reflector boards must differ from that of the backdrop, or the silver will appear to merge with the backdrop. So, for example, if you are photographing silver on a white backdrop, the reflector boards should not be white. Try different shades of reflectors as well as backdrop until you are satisfied with the effect.

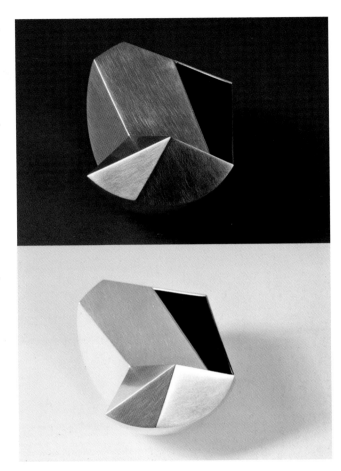

top & above *Ane Christensen,* Facet Bowl, *2009. Sterling silver, Height: 6cm (2½in). The same piece photographed on different background colours.*

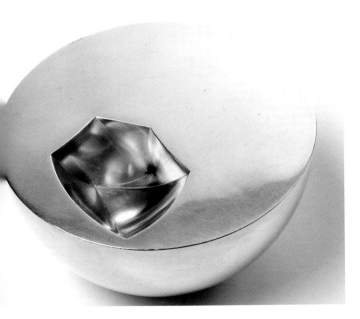

Ane Christensen, Introverted Bowl, *2009. A light grey reflector is placed above the object..*

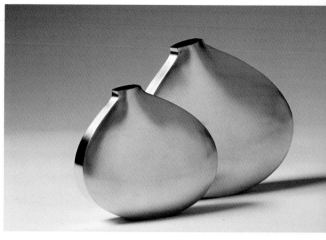

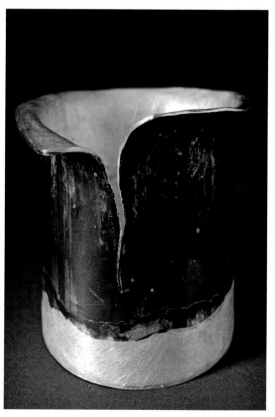

above: *Adi Toch,* Tactile Vessels, *2009. Silver, gold-plated gilding metal, 9 x 7cm (3½ x 2¾in). Studio light is softened by bouncing it off the ceiling to prevent glare.*

top right: *Angela Cork,* Billow Vases, *2008. Sterling silver, 13 x 11cm x 4cm (5 x 4¼ x 1½in) and 16 x 14 x 5cm (6¼ x 5½ x 2in). Large white reflectors are placed around the objects. Different shades of reflections on the surface of the vases are created by placing reflectors at various distances and angles from the object.*

centre right: *Simone ten Hompel,* But Where is Lucy?, *2007. Precious white metal. Height: 24cm (9½in). A studio light is placed directly over the piece so that the light can reach the small details submerged in the hole.*

right: *Louise Loder,* Cracked Pot, *2010. (Part of series of 10 Play Pots.) Sterling silver with firescale. Height: 5cm (2in). This small piece is photographed using a macro lens.*

Ceramics

When photographing ceramic work it's important to light the object so that both the form and the texture of the object are enhanced.

A low light directed from the side of a bowl or plate will create a shadow inside as well as the outside thus revealing its form.

Soft light works best on the surfaces of hard, glazed ceramic as hard light will cause unwanted glare. Some reflection from a soft light is desirable with glazed ceramic work to show the glazed surface. Make sure the reflection from the light doesn't appear where there is important detail – if this happens, carefully reposition the light.

below left: *Barry Steadman,* Squared Blue and Yellow Vessel, *2009. Thrown red earthenware clay, with coloured slips and stains. Height: 15cm (6in).*
The object is lit with a studio light and soft diffuser attachment. A small reflection reveals the glazed surface.

below right: *Christie Brown,* Sexy Beast Pussy, *2009. Porcelain. Height: 28cm (11in). This piece has a shiny glaze on the shoulder which is revealed by the reflection from the light.*

 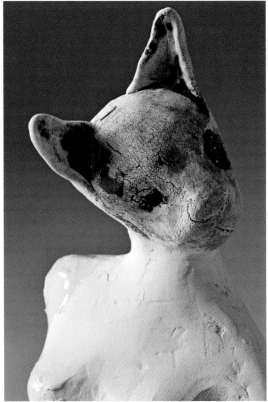

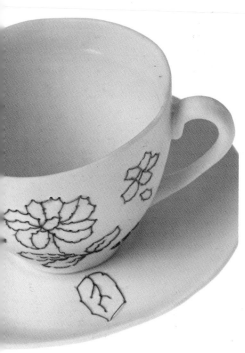

Clare Cole, Forget Me Not, tea cup and saucer, 2006. Porcelain. Height 10cm (4in). Photographed with a long depth of field to show the details of the piece.

Consuelo Radcliff, Wondering, 2010. Earthstone clay, high fired to 1120°C, oxide stains, glazed. Height: 29 cm (11⅛in). Here the piece is photographed with a dark background and a hard light – the textures in the piece are revealed and the shadows add some drama.

Consuelo Radcliff, Wondering, 2010. Here the piece is photographed on a white backdrop and lit with two soft lights - the feeling of the piece changes with the choice of backdrop and light.

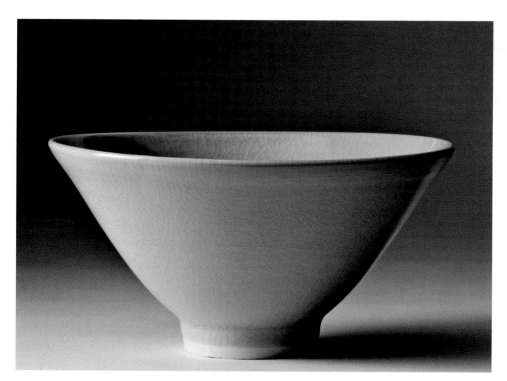

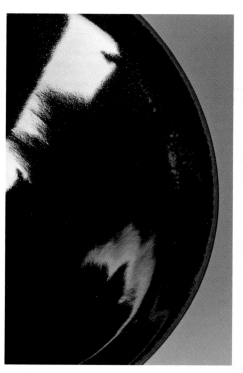

John Masterton, Celadon Crackle Glaze Bowl, 2010. Valentine Royale porcelain. Diameter: 20cm (8in). The bowl is lit with a soft studio light from a low sideway position, a white reflector is placed on the shaded side.

John Masterton, Tenmoku Glaze Bowl (detail) 2010. Porcelain. Diameter: 20cm (8in). The close up of the bowl shows the detail in the glaze.

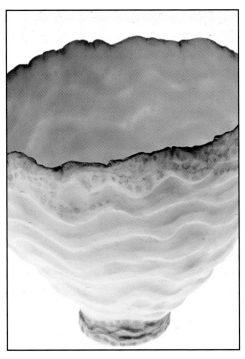

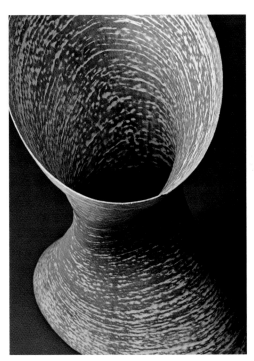

Kate Adams, Stripes, *2009. Grogged black stoneware clay. Height: 8cm (3¼in). The piece is lit by a hard light directed from a low side angle to emphasise its texture and form.*

Joy Trpkovic , Ripple Carved Pinched Vessel, *2009. Pinched, carved porcelain with glaze enamels. Height approx. 25cm. This piece is backlit to show the delicate translucency of the porcelain.*

Sarah Scampton, Untitled, [twisted elipse, pale grey], *2010. Low-fired stoneware clay. Height: 63cm (25in). This piece is photographed from a high viewpoint to see the darkness of the void in the vessel.*

left: *Matt Smith,* It Wasn't What We Wanted For Him, *2009. White earthenware with underglaze colour, decals and lustre. Height: 21cm (8¼in). The piece is photographed with a softbox attached to the studio light to prevent glare in the hard glaze.*

above: *Helen Johannessen for Yoyo Ceramics,* Fruit Kitchen Tidy/Spoon Rest. *Glazed earthenware Apple, Banana, Pear & Orange. Length: approx. 12–14cm (4¾ x 5½in), height: 2cm (¾in). These bowls are very shallow so, to make the concavity visible, the light is placed at a very low angle to create shadows inside the bowls.*

127

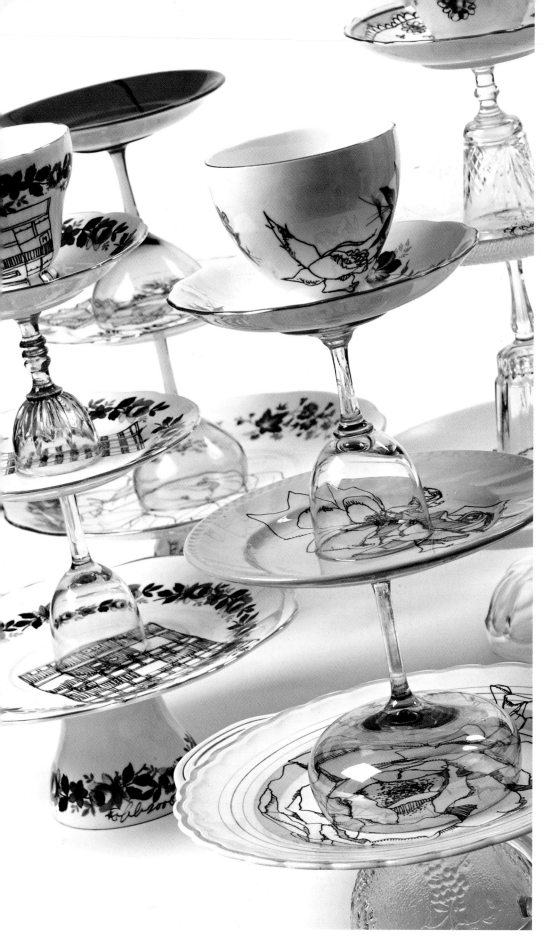

If the ceramic object has a matt textured surface, light the work at a sharp angle if you want to emphasise the texture. If the pie has a matt surface you can use hard light.

Some delicate ceramic work is slightly translucent, so capture t using backlight in the same wa as in the light set-up for glass.

this page
Esther Coombes, Cake Stands, *2009. Up-cycled hand drawn china, Height: approx. 25–35cm (10–13¾in). A long depth of field used both to show the patterns on the diffe. cake stands, and to keep them all in focus.*

opposite
left: *Alison Evans*, Flat Necklace, *2007. Silve with ruby in clasp. The piece was photograp with a macro lens and a very shallow depth field.*

above right: *Alex Ramsey*, Glass Jeweller Collection, *2004. Fused glass and 22ct gold leaf. Gold-plated silver connections. Width. (bracelet) approx. 3.5cm (1⅜in), (necklace approx. 2cm (¾in) square. The pieces wer photographed on a backlit sheet of Perspe.*

below right: *Andrew Lamb*, Earrings, Changing Colour series, *2006. 18ct yellow white gold. Height: 25mm (⅛in). The piece. are reflected in the sheet of perspex which surrounded by grey reflectors.*

Jewellery

You will need a macro lens or extension tubes to get close up to small jewellery work. Remember that when using a macro lens or extension tubes the depth of field is very shallow so, if you want the whole piece to be sharply in focus, set the f-stop to a high f. number. Arrange your work carefully and try to create interesting compositions, also try different camera angles. Polish the pieces well and use a compressed-air duster to remove any small specks of dust.

It may take a particular kind of light to bring out the specific quality of your piece but generally soft light is better as it won't cause glare.

Sparkly stones can look lovely in hard light, but be careful to avoid hot spots on any surrounding metal.

Stones with translucent qualities look better backlit, so capture this using backlight in the same way as in the light set-up for glass.

With reflective jewellery, as when photographing silver, use reflectors to create grey, black or white reflections on the piece and also to eliminate unwanted reflections. Wear black clothes to make sure no colour reflects in the jewellery. A light tent can be very useful as it will create a soft light as well as blocking any reflections.

Have materials such as BluTak (blue tack) and fishing line handy for hanging or propping your work up or fixing it in different positions.

To create a soft reflection of the jewellery, try placing the piece on a sheet of Perspex. Changing the angle of camera will make the reflection more or less visible. Looking through the camera's viewfinder, move the camera up and down until you are happy with the effect.

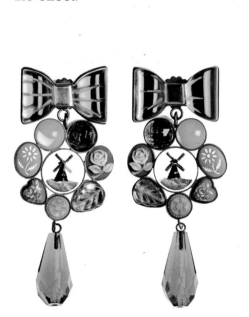

above: *Beth Gilmour,* Shaded Necklace, *2008. Silver and rutilated quartz. 58.8cm (23cm) in length. The necklace is arranged to create a sense of movement in the composition.*

left: *Grainne Morton,* Windmill Collage Drop Earrings, *2009. Oxidised silver, found objects. Length: 5cm (2in). The earrings are backlit to show the translucency of the stones.*

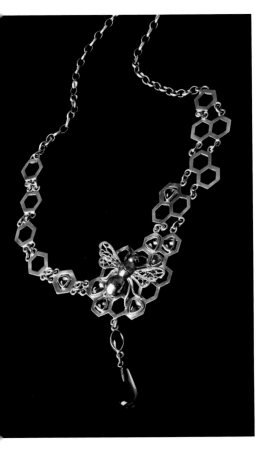

top left: *Briony Eastman,* Bee on Honeycomb, *2009. Silver and 18ct gold, hung with an amber drop and set with peridots, pink tourmalines and rough diamonds. Height: 21cm (8¼in) from clasp to bottom of drop. Photographed on black velvet.*

top centre: *Briony Eastman,* Bee on Honeycomb, *2009. Photographed on white backlit Perspex.*

top right: *Jacqueline Cullen,* Hand carved Whitby Jet Pendant With Crystals On Linen, *2008. Whitby jet, crystals, linen 18ct gold. Diameter: 8cm (3in). The pendant is photographed from a slightly low viewpoint to show the granulation.*

left: *Katy Hackney,* Ovals Brooch, *2007. Plywood, vintage and new Formica, silver, steel. Height: approx. 9cm (3½in). Photographed with a macro lens set on a long depth of field to clearly show the details in the piece.*

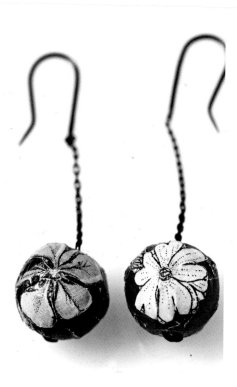

Laura Long, handcrafted beads made using traditional paper techniques, 2010. Length: approx. 50mm (2in). Photographed with a shallow depth of field to de-emphasise the hooks and instead draw attention to the flower patterns.

Katy Hackney, Flower Necklace, *2001. Silver, vintage Formica, approx. 45cm x 4cm (17¾ x 1⅓in). Photographed on white paper with soft light to make the shadows soft and to avoid glare.*

Rachel Galley, The Amore Heart Locket, *201 Silver. Length: (chain) 80cm, (31½in), (heart, 4.5cm x 4cm (1¾ x 1½in). Photographed wit the chain creating a sense of movement in the composition.*

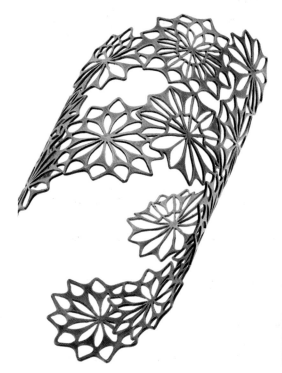

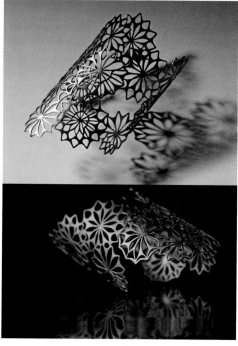

left and far left: *Kelly Nacht,* Islamic Geometric Pattern Cuff, *2009. Copper. Heig 5cm (2in), length: 5.5 cm (2¼in). The brace is photographed on different backdrops usi different lighting.*

far left: *Backlit on white Perspex. Photogra using a macro lens with long depth of field.*

left (top): *Spotlight on white paper. Photographed using a macro lens with fairl long depth of field.*

left (bottom): *Soft light on black mirror pa Photographed using a macro lens with shall depth of field.*

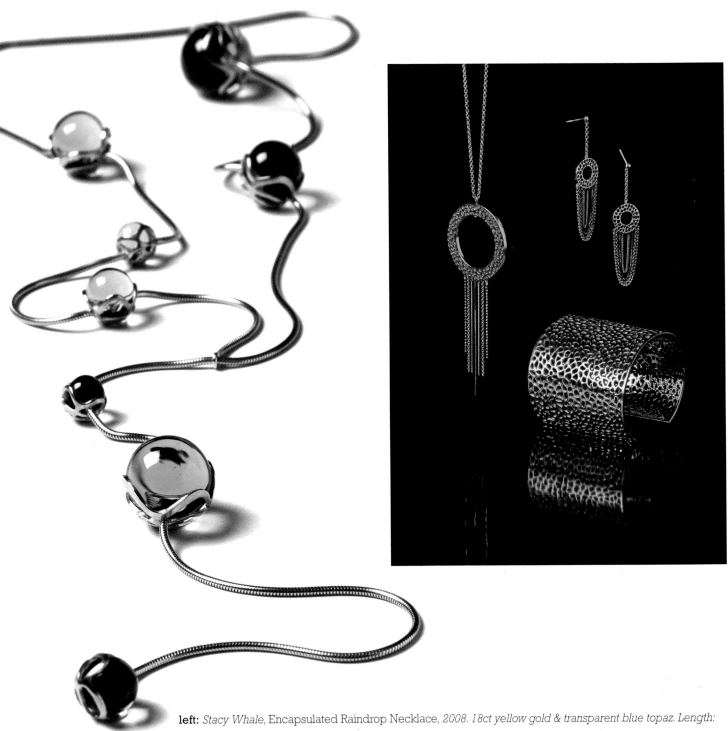

left: *Stacy Whale, Encapsulated Raindrop Necklace, 2008. 18ct yellow gold & transparent blue topaz. Length: 78cm (30¾in).*
A light placed at a low angle shines through the blue topaz onto the white paper background creating pools of blue light.

above: *Rachel Galley, Enkai Sun Tassel Pendant. 18ct gold plated silver. Diameter: (chain) 80cm (31½in), (disc) 4cm (1½in).*
Enkai Sun Loop Earrings. 18ct gold plated silver. Length: 6cm (2¼in).
Enkai Sun Cuff, 2010. 18ct gold plated silver. Height: 59mm (2⅓in).
Photographed on black Perspex with black velvet in the background. The earrings are hanging from fishing line.

133

Lamps and Lights

When photographing lamps or candleholders, you need to balance the light from the lamp with the external light illuminating the outside of the lamp and the backdrop. Place the camera or light meter close to the object and take a light reading. Turn down the studio lights until you get the desired effect. If your light source is coming from a window, block some light with fabric.

Depending on the design of the lamp or candleholder, sometimes no external light is needed; equally, sometimes having external light illuminating the backdrop and other details of the lamp works better.

For photographing lamps and candleholders with a digital camera, the white balance should be set to tungsten 'bulb setting'. If using film, use tungsten-balanced film.

 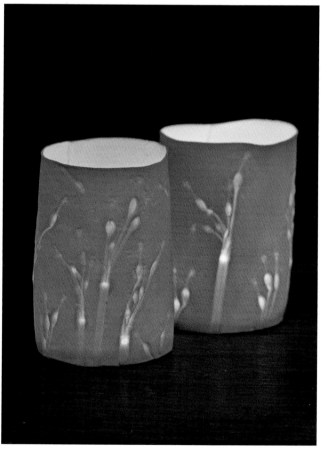

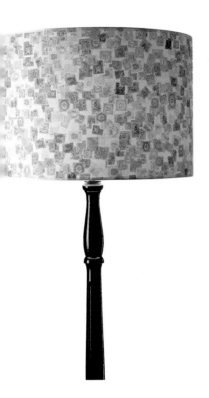

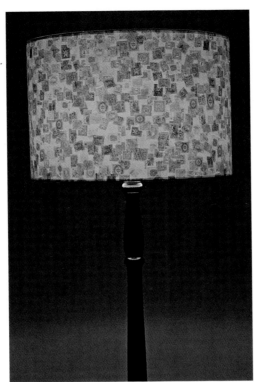

far left: *Catherine Hammerton,* Stamp Print Drum Shade, *2009. Digital print, cotton tape. 24 x 46cm (9½ x 18in). Two studio lights are directed onto a white background – the power of the studio light is brighter than the light from the lamp to make the background white.*

left: *Catherine Hammerton,* Stamp Print Drum Shade, *2009. Here the studio lights are switched off and the background is lit only by the lamp.*

Flavia Del Pra, Zebra, Lava and Giraffe Pattern, *2010. Porcelain, translucent glaze, hand carved. Height: 19cm (7½in). The window light is blocked making the background darker and the surface of the porcelain less visible.*

Flavia Del Pra, Zebra, Lava and Giraffe Pattern, *2010. Light from a window brightens the backdrop as well as the surface of the porcelain.*

Liz Emtage Ceramics, Narcissi Tea Lights, *first made 2010. Porcelain clay, 13 x 10cm (5 x 4in). Light from a window illuminates the outside of the tea lights as well as the wooden table.*

Liz Emtage Ceramics, Narcissi Tea Lights, *first made 2010. Some window light is blocked thus darkening the background and the white porcelain surface of the tea light.*

Two studio lights with photo umbrellas set on equal power are placed at an equal distance from the artwork. Black velvet is hung from a pole. The camera is placed behind the cloth with only the lens passing through the fabric.

Photographing 2D Work

Illuminate the artwork with an even spread of light using two lights with equal power reflected from white surfaces – photographic umbrellas, white walls or reflectors. Place two lights on either side, an equal distance apart, at the same height as the artwork. Take light readings from all corners and at the centre of the artwork, making sure these are all the same. Move your lights, or adjust the power if the light readings differ, until the light is evenly spread with the same readings all over.

Assuming the work to be photographed is either square or rectangular, the edges of the work must be parallel in the photograph. Start by hanging your work in the middle of a large wall, making sure it's level by using a spirit level. Place the camera on a tripod with the lens pointing at the centre of the art work, with the camera on the same plane as the art work.

If your camera has a grid display pattern of horizontal and vertical lines, it will help you with the parallels. Some digital cameras have this option in the menu settings.

Use a spirit level on the camera to straighten the horizontal and vertical angles. Look through the viewfinder to make sure the art work is centred. Adjust by moving the tripod up or down and left or right, then check the spirit level again to be certain your camera is still straight.

Eliminate any unwanted reflection and glare by moving the lights further apart and further back, in line with the art work. Some reflections and shadows in 2D work can be desirable as they reveal the texture of the paint or materials. Try rotating the work 90° and decide where the shadows or reflections look best.

If you are photographing art which is behind glass, hang a large black cloth in front of the camera, with a hole for the lens, and shoot from behind the cloth (as the image shows on p.136). Looking through the viewfinder, make sure any unwanted reflections are covered by the cloth, so that the only thing you see reflected in the glass is the blackness of the cloth.

A Polaroid filter can also be used to eliminate reflection. It is placed on the lens and rotated whilst you look through the viewfinder until you see the reflections disappear.

opposite: *The gallery installation is taken from a high viewpoint to clearly see the objects on the tables. The spotlights on the pieces are turned down in order to balance the ambient window light. Photographed with a long depth of field.*

inset: *Close up of some pieces photographed with a shallow depth of field using window light.*

Exhibitions and Trade Shows

I f you are exhibiting in a gallery or trade show, you may want to record your work *in situ*. You will need a tripod, a cable release, and a range of lenses with different focal lengths from long to wide angle.

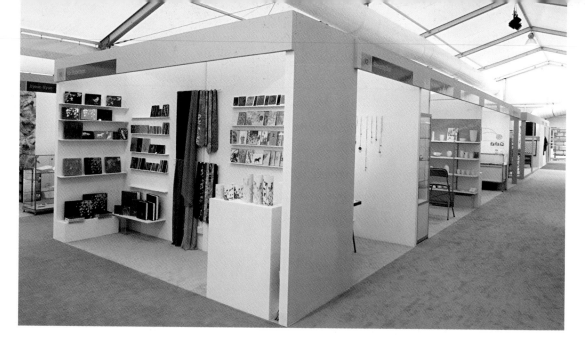

top: *Kim Robertson at Origin, Craft's Council exhibition, 2008.*

bottom: *Matthew Durran, glass installation at Origin, Craft's Council exhibition at Somerset House, 2008.*

Use long exposures and small f-stops to get everything in the exhibition space sharply in focus. Place the camera at a viewpoint that minimises distortion.

Take some light readings around the exhibition space and make sure the readings don't vary too much between the dark and light areas. If the light readings are very uneven, try switching off any bright spotlights.

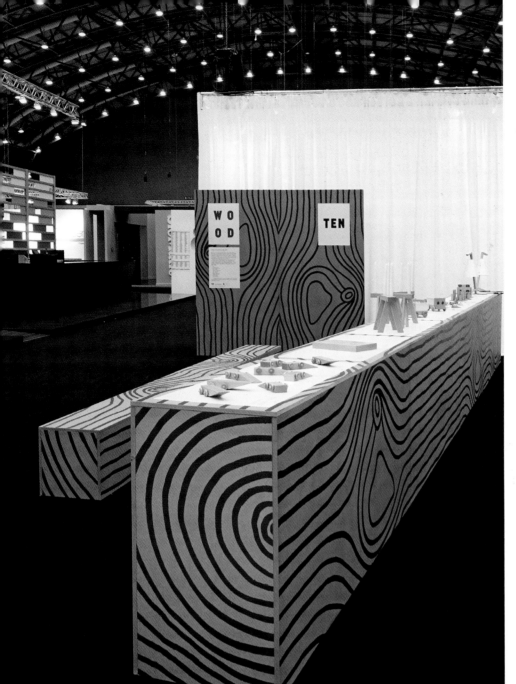

above: *WOOD by Ten, a Crafts Council Touring Exhibition.* **top right:** *Tomoko Azumi at the Craft Council exhibition, 2008.*

right: *Stephen Bretland,* Candleholder, *exhibited by the Craft Council, 2008.*

Look for unwanted shine and reflection in the surfaces, and either switch off the light that's causing the reflection or move your camera to a slightly different position. If you have a polarizing filter, put this on your lens and turn it until the reflections disappear.

Include some close-up photographs of your work as well as recording the exhibition from different corners of the room.

Commissioning a Professional Photographer

If you sometimes feel that you'd rather commission a professional photographer, then take time looking at different photographers' work. Look at craft magazines, cards, brochures and other makers' websites. Find a photographer whose work you admire and who is right for your work. Speak to or email them, making sure that you trust them and feel they would be good to work with.

Don't make the mistake of commissioning a photographer whose work you like but who is unfamiliar with photographing applied arts. Also, don't be tempted to choose one over another based only on price because, if you are unhappy with the results, it could end up costing you more in time and money.

When you meet the photographer, ask any questions and clarify any details before the session. Explain how you plan to use the images. Check usage rights and prices (some photographers retain the right of use and will charge for certain types of usage of the images). Ask if the price includes post-production, approximately how many images you will receive, in what file type and size your images will be delivered, and what the turnaround time will be.

It might be helpful to show the photographer some images you like in order to give an idea of what you want, but only offer this as a guide; it's important to respect your chosen photographer's opinion and expertise. Talk about any ideas

you may have. You might also show previously taken images of your work and explain what there is about them that did or did not work for you.

Talk to the photographer about your work: explain how it's made and about the materials you've used, as well as your creative thoughts. Don't forget to mention anything that might seem obvious to you but which might easily be missed by the photographer: Which is the front and which the back of the object? Which is the right way up? What is its use?

Establish how the photographer works: some will want to work on their own whilst others might prefer you to work with them and help with the styling.

It can be good to work with a single photographer in order to build a good relationship and understanding. If you are planning to have your work photographed regularly, it might also be good to use the same photographer in order to achieve continuity.

Index